Tom Wesselmann

cantz

Tom Wesselmann

Thomas Buchsteiner Otto Letze

Contents

Preface

It is really only now becoming possible, aided by historical distance and a retrospective view of American Pop Art of the 1960s, for us to appreciate the Pop rebels of those years in terms of their individuality, their differences and their immense creative potential.

These artists took up the banality of everyday life as their iconographic material, presenting its themes on gigantic surfaces or in monumental installations. Because of their disturbing quality and evocative power these works soon found their way into museum collections.

Tom Wesselmann is one of the very few major artists who have not only retained a unique language of images but have continued to develop it in an intelligent and sophisticated manner long after the end of the great Pop era.

"I'm just a representational artist dealing with my own evolution of the representational art that came before me", he says today. But we all know that with his bathtubs, nudes, fruit bowls and curtains he has created icons not only of Pop Art but of art history as well.

While his sweeping, almost casual sketches can be compared with the charcoal drawings of Matisse, his large-scale compositions have set new standards, and his world of images has opened up avenues to international comprehensibility.

It was necessary to show Tom Wesselmann's work in its full retrospective breadth. Although his many prominent contributions to all of the major Pop Art exhibitions have never failed to underscore the quality of his work as a Pop Artist, these events have not provided viewers an opportunity to comprehend his uniqueness, his individuality and quality, which transcend the boundaries of the Pop era. A backward look at the entirety of his work reveals that Tom Wesselmann is far more than just a Pop Artist.

Thomas Buchsteiner Otto Letze

Telling it like it is

Marco Livingstone

Everything in Tom Wesselmann's art is what it is, no more and no less. To an even greater extent than most of Pop Art colleagues, he has dedicated himself, in the words of a popular song of the 1960s, to "tell it like it is". The observation made in 1964 by another American artist, Frank Stella, of his own abstract paintings – "what you see is what you see" – could be applied as truthfully to Wesselmann's production. Yet as the interpretations of commentators for more than thirty years have made abundantly evident, it is easy for us to be distracted by the assertiveness of his imagery – the sexually provocative women and images of food or manufactured objects that define his world – to make certain assumptions about the presumed social content of his art or about its role as a form of commentary on consumer society.

While Wesselmann takes particular exception to such a reading of his art in terms of subject matter, and indeed to the literary connotations of the images as the expense of their purely visual function within a given work, there is no avoiding the fact that he has demonstrated such a strong attachment to particular kinds of motifs that they must have some significance. Their meaning, however, may be much more self-apparent than we might care to believe. They are all, in one way or another, evidence of states of heightened pleasure, such as we experience when looking at or touching the face or body of a person we find attractive, or when eating, drinking, smelling the fragrance of flowers, listening to music or lolling on the beach under a hot sun.

Almost without exception, Wesselmann's images appeal to the pleasure principle within us and contribute to the sense of delectation exuded on a more visceral level by the conjunction of particular shapes, textures and colors. The selection of motif is only one part of the equation by which the artist conveys sensations of desire fulfilled to the point of satiation. Even if we, like the artist, are non-smokers, we can still understand that for others a cigarette represents a form of oral satisfaction as acute as that offered by more nutritional forms of refreshment. If we don't like the music playing on one of the real radios incorporated into his early works, or the program on one of the television sets, we are in principle at liberty to change the channel until we find what we want. The scenic landscapes or the reproductions of works of art by Matisse, Renoir, Van Gogh, Modigliani and others may or may not be to our own taste, but we still intuitively understand that each of these views of the world constitutes a way of appreciating aesthetically what this world has to offer.

Early 1n 1933 Wesselmann repeated to me a point that he has made more than once in the past without, perhaps, ever being fully believed: that far from developing his signature style as a consequence of a particular involvement with subject matter, he deliberately chose to work within the most conventional categories of art as a way of freeing himself from the influence of American Abstract Expressionist painting, which he had come to love as a student in New York in the late 1950s. Had he continued to emulate painters such as Willem de Kooning and Jackson Pollock, famed for their violently gestural application of paint on vast canvases, he would probably have been condemned, like others, to being perceived simply as a follower in the shadow of giants. To make his presence felt, he would have to find another way of creating work that had a similar power but that was based on entirely different premises, even if this meant overturning all the assumptions that he had come to cherish about contemporary art.

"When I made the decision in 1959 that I was not going to be an abstract painter, that I was going to be a representational painter, I had absolutely no enthusiasm about any particular subject or direction or anything. I was just starting from absolute zero. I only got started by doing the opposite of everything I loved. And in choosing representational painting, I decided to do, as my subject matter, the

history of art: I would do nudes, still lifes, landscapes, interiors, portraits, etc. It didn't take long before I began to follow my most active interests, which were the nudes and the still lifes. Portraits, I virtually left untouched. Landscapes, it took me a long time to get around to that; my earliest ones just simply were excuses to use parts of car billboards. With the Interiors, I felt a little bit like it was a new category: it was an interior, but because it was so peculiarly fabricated with real elements, it was becoming something else, so by this time I'm not thinking in those same terms any more, I'm just making paintings.

I called them *Great American Nude # 1, Still Life # 1,* etc. because I didn't want to give these works – which at the time were quite novel, and lent themselves to all kinds of interpretations or jokes or whatever – I didn't want to feed the fire of their unusualness by titles. So I decided the title would just be numerical, as stripped down as I could make it."

In spite of his protestations against literary interpretations of visual art, Wesselmann has acknowledged that it was through his reading around 1960–61 of Henry Miller's *Tropic of Cancer and Tropic of Capricorn* – novels that were considered highly controversial at that time because of their explicitness about sexuality – that he felt encouraged to address his own sexual outlook more directly. The very title that he devised for the series in which these interests were most openly expressed, *The Great American Nude,* carries overtones not only of the The Great American Dream but also of the The Great American Novel to which writers were often said to aspire. The self-deprecating humor indicated by his choice of such a portentous and ambitious phrase, however, was also a useful way of shielding himself from the highly personal nature of the material with which he was dealing. His seven-year marriage to a girl he had met at college, Dot Irish, had recently collapsed, and after a lonely period on his own he started going out with a fellow student, Claire Selley, whom he had met in 1957. They began seeing each other in the summer of 1959, after he had left his wife; she became not only his girlfriend, and in 1963 his wife, but also his main model.

Wesselmann's decision to celebrate, through his work, the sexual and emotional fulfilment that he found in this new relationship could have left him feeling vulnerable and emotionally exposed, particularly at a time when he and other painters of his generation had begun to disassociate themselves from the Romantic notion of the artist as a special being or as a tortured soul. How could he seek to overturn the exaggerated subjectivity of the Abstract Expressionists while dealing with such intimate and private matters in his own art? The dilemma must have been intensified, shortly after he had produced the collages in which this imagery first surfaced, by his first experience of psychoanalysis, which from 1960 forced him to come to terms with powerful impulses that had affected both his life and his art. In sessions that took place on average four times a week, he was asked to examine, among other things, the erotic content of his dreams.

"There was a time, when I was a student, that my emotional strength was so fragile, especially as I was undergoing this profound change in my life. I was throwing everything out and I was trying to become a painter. I went to painting class once or twice, fresh in the morning, I'd take my brush and make one bold stroke, and that was the end of the painting for the day; I was emotionally too frail to continue. I was very unwell at that time. Analysis made me well, so I can do that and carry on all day long, seven days a week if I have to. Speaking in relative terms, it made me healthy, so that I could do what I wanted to do and not have to retreat from it on some emotional level that I couldn't really comprehend. But that's a very complex issue to deal with. It also caused me to think intellectually, and analytically, very deeply about a number of things that I had never done before."

Psychoanalysis, to which Wesselmann has returned as a way of deallilng with major events throughout his adult life, thus made him strong enough, he recalls today, to be able to paint. His fears that understanding himself too well might ruin his creativity proved unfounded. Nevertherless, it would not have seemed appropriate at that time to make apparent the extent to which the pictures reflected circumstances in his own life. It was useful, therefore, to present the nudes in a more detached way as the extension of an artistic tradition. More than that, eroticism provided a powerful means of circum-venting the usual reticence that we experience as viewers when we are confronted with a work of art, as it did for other artists of the period associated with Pop Art, such as the Californian Mel Ramos and the British painter and sculptor Allen Jones. It is difficult to look at such images with indifference, or to defer to them respectfully as we might have been trained to do when looking at a work of art. By the same

token, we cannot easily explain them away intellectually, since whatever our point of view may be, we are likely to respond to them almost automatically when we first see them, bringing to each encounter our own associations and personality.

Wesselmann's solution to dealing with such personal matters was to use the body gestures of his girlfriend, during shared intimacy, as the basis for public statements of outlandish directness. The artist recalls that instead of copying poses or gestures, "I made poses as metaphors for our sexual intimacy and attraction. They represented her sexuality, not necessarily her." The sexual abandon of some of the postures, as he points out, far exceeds that of the soft-porn and pin-up imagery that was then in circulation in magazines such as *Playboy*, the first issue of which appeared in 1953, or on calendars. With their nipples hardened in a state of excited anticipation and their legs often shown spread apart in open invitation, revealing shaved vaginas, these women are without shame and devoid of prudery. Considering the fact that censorship was still strong in the United States in the early 1960s, and that such overt postures gained currency only a few years later in hard-core pornography, the confrontational quality of these images cannot be overstated. Since the early 1970s, in the wake of the feminist movement, they have come to be reinterpreted by some commentators as signs of the objectification of women as mere objects of male sexual desire. At the time, however, they were clearly intended as radical expressions of the new openness and honesty about sexual matters that came to be associated with the 1960s.

The restrained eroticism already evident in the small collages of 1959–61 became magnified, and consequently a much more conscious feature, when Wesselmann began working on a much larger scale in 1961. The first of his large canvases, *Great American Nude # 1,* shows the figure in a seductive but in a matter-of-fact rather than provocative posture. She is shown simply to be relaxed in her nudity; the reclining position is fairly indolent, like that of someone about to take a nap. The sexiness of these early figures by Wesselmann resides mainly in their lusciously curvaceous forms and succulent color, that is to say in their essentially abstract qualities, and it therefore follows that is the idea, rather than the reality, of sex that is presented in these pictures.

"From the very beginning I did not put faces on them, because I liked the painting to have a kind of action that would sweep through it, and certain things could slow that down: too much detail could slow it down. A face on the nude became like a personality and changed the whole feel of the work, made it more like a portrait nude, and I didn't like that. So I used no features, from the beginning."

It was, in fact, one of the most schematically treated of all these figures, *Great American Nude # 12* of 1961, that happened to lead to the concentration on lips, breasts and genitals that gives such a heightened sense of eroticism to Wesselmann's later works. The model, Judy, who had posed for this painting, exclaimed, on being shown her image, that she liked the picture so much that she felt inclined to kiss it, presumably in the spot where the mouth would be. Taking his cue from this chance remark, the artist began to incorporate a realistically rendered mouth in otherwise featureless faces, first by collaging a photographic pair of lips – as in *Great American Nude # 27* 1962 – and later by rendering them, like the other elements, in paint. In an early example of a nude magnified to gigantic scale, *Great American Nude # 53* 1964, the oversized mouth with lips parted in seemingly lascivious anticipation is paired with perfectly symmetrical pink nipples. While this pair of collaged lips had actually been cut from a billboard advertisement for Royal Crown cola, showing a woman smiling with pleasure at the thought of having a refreshing drink, in their new context the imagined pleasure takes on a more purely sensual dimension.

In retrospect, it looks like a foregone conclusion that some of Wesselmann's most notorious women, the shaped canvas *Smokers,* would end up as all mouth, while others would be represented in the form of a single breast, as in *Seascape # 19* 1967. In the artist's *Bedroom Painting* series, such as *Bedroom Painting # 13* 1969, the scale of the still life elements was radically enlarged by presenting them in relation to parts of the body seen in extreme close-up. The *Bedroom Tit Box* of 1968–70, a sculptural representation of this series, is perhaps the most infamous consequence of this development: when it was first shown at the Sidney Janis Gallery in New York, set into a false wall, a young model dropped her bare breast through the top of the box, so that this fragment of reality was displayed alongside the fabricated and painted elements. Even when Wesselmann began in works such

as *Bedroom Painting # 39* 1978 to represent all the features of a woman's face shown in close-up – perhaps partly, he acknowledges, in response to criticism that he had not been portraying the whole person – attention continues to be concentrated on the opened mouth as a sign for unleashed desire or orgasmic satisfaction.

"When I started working big, eroticism was a *component* of my work. It was just like part of the collage, like everything else. It was not the point of the work, because my work has always been more formal, more composed, than to be that involved with making something erotic. But eroticism was, especially in the beginning, part of my work. Originally it was part of my work like Abstract Expressionist brushwork was: it was – we didn't have the expression then – 'in your face'. Since I couldn't use the Abstract Expressionist brushwork any more – I had dropped that – I had to find other ways of making the painting, the *image,* aggressive. And moving forward like that – Abstract Expressionist paintings were always moving forward, and the shapes were constantly off the canvas, in your eye, in your face – eroticism was one of the tools for me to try to accomplish that. At the time I actually did more hairless vaginas than with hair, because that seemed to make the eroticism a little bit more of a feature. It was like the color red for me, a strong element to use. As I went into the nudes more, eroticism became less pertinent. I had to make a choice in two directions: whether to make the nudes real perhaps sensual, or unreal. And I went for the real and sensual, which tended to keep the nudes more or less on a real scale. In fact, in one or two of my earlier works a woman lay down on the board, and I drew around her and painted that. So keeping it on a human scale made it a little more sensual."

The emergence of eroticism in Wesselmann's work in 1961, in the *Little Great American Nudes* and the large versions of these that soon followed, coincided precisely with his introduction of images that function as blatant signs of American society. While he is quick to discount any interest in such motifs as cultural signifiers, and to deny that he was either celebrating or satirizing the way of life they represented, the aggressiveness with which their American quality is insisted upon is as confrontational as the sometimes shocking explicitness of the sexuality. By the early 1960s, Wesselmann had decided to choose, wherever possible, images that were explicitly American in origin. As a matter of convenience, these were often taken from mass media sources – magazines, advertisements, billboards and the like – not because he wished to base his art on consumer culture, but because this is the material that was most readily available for his collages. Similarly, when he began to incorporate not just flat images but actual objects, in the process moving from collage into assemblage, it seemed natural to use familiar things that were readily at hand.

Having become accustomed to the idea of working on his own, isolated and apparently removed from the mainstream of artistic activity, he did not altogether welcome the discovery that other artists had begun to use similar imagery in their works and to allude – sometimes for quite different reasons – to the products of consumer society. In December 1961, at the time of this first one-man show at the Tanager Gallery on Tenth Street, he was told by Ivan Karp of the Leo Castelli Gallery about the work of Roy Lichtenstein and James Rosenquist, who soon afterwards had one-man shows at the Castelli Gallery and Green Gallery respectively. On investigating their work he was relieved to discover that – in his view, at least – they had little in common. A few months later, in early 1962, when he had begun to include household objects in his assemblages, he was perhaps even more concerned to hear that his old friend Jim Dine had begun to attach similar items to his own paintings. Again, he was pleased to discover that they were using the materials in a different way. Since Dine emphasized the anthropomorphic quality of manufactured objects and presented them in violent contrast to their painterly setting, rather than simply as elements of a composition that stood in for reality, each artist was able to continue making his works without concern.

Wesselmann's art was quickly promoted as part of a new movement, Pop Art. When he was offered the chance to be included in an international survey exhibition, *New Realists,* at the highly respected Sidney Janis Gallery in New York, he accepted in spite of his reservations because he was aware that it would give his work much wider exposure and consequently make it easier for him to make a living from his art. Controversial in its aesthetic assumptions, brashly aggressive, humorous, full of easily recognizable and seductive images of contemporary life, and often shocking to conventional sensibilities, Pop Art enjoyed almost instant notoriety in the press and equally rapid acclaim from

collectors and the general public. The old guard of the art world was skeptical, and remained so for many years, but the reputations were sealed of the artists who were judged to be the prime movers. Journalists who had found it difficult to explain abstract art to a resistant audience suddenly had more than enough to write about, even if they contented themselves with an anecdotal roll-call of Pop imagery at the expense of a more profound understanding of its aesthetic implications. Understandably, Wesselmann felt almost immediately that too much attention was paid to the subject matter, and to its potential for nostalgia, and he came to the conclusion that the term was therefore more dangerous than helpful.

In reply to the first question put to him by G. R. Swenson in one of eight interviews with Pop artists published in *ARTnews* magazine in November 1963 and February 1964, Wesselmann said: "I dislike labels in general and Pop in particular, especially because it overemphasizes the material used. There does seem to be a tendency to use similar materials and images, but the different ways they are used denies any kind of group intention." Seeking to disassociate himself from the movement and particularly from his audience's preconceptions about the role played by consumer images, after 1964 he deliberately eliminated the most overt references to brand names. He repeatedly denied the presumption that his images of female sexuality were derived from the mass media source of pornographic magazines. Even in adapting processes from commerce – such as the illuminated gas station signs of brightly colored, molded plastic that served as the starting point for works such as *Still Life # 46* 1964 – he played down the connection between the two, both in his explanations and in the choice of imagery for the works themselves, so as to isolate attention on the purely formal qualities of the chosen medium. Only now, thirty years later, has his recalcitrance towards the label begun to soften. Like the American comedian Groucho Marx, who famously claimed that he would not wish to join any club that would have him as a member, Wesselmann has demonstrated an astonishing resolve not to be welcomed into the ranks of a movement of which he was one of the undisputed founders.

"I was a Pop artist," he acknowledges today, "to the extent that I deliberately chose American imagery. I did not like European imagery. Sometimes I did choose European imagery, because it was all I had." For example, for the *Landscape* paintings that he produced in the mid-1960s, such as *Landscape # 2* 1964, he used Volkswagens rather than American cars, mainly because the choice of appropriate poster images was fairly limited and the German manufacturer proved especially helpful. He recall that he had a couple of posters of beautiful American cars, but that they were either too big or inappropriately depicted for his intended use. Volkswagen Beetles were, in any case, very common at that time in the United States, making them part of the culture. "By and large I only felt comfortable with elements from my own culture; the others seemed too self-conscious, somehow. So to that extent, I used what was around me, so my culture was what I used. But I didn't use it for cultural reasons, it was not a cultural comment."

Still Life # 33 1963, one of a series of enormous works that mimicked the scale and proportions of the billboards from which their printed images originated, displays a full ready-made meal – an overstuffed submarine sandwich, a can of Budweiser beer, an orange for dessert and some Pall Mall cigarettes for afterwards – with the same monumental arrogance of the larger-than-life advertisements. Propped up on her elbows, *Great American Nude # 27* turns her face, and specifically her lips, towards a row of mouth-watering ice-cream sundaes, sodas and milkshakes. A giant jar of Hellman's Real Mayonnaise sits regally next to a perfectly formed, perfectly red, tomato on the formica shelf of *Still Life # 48* 1964. The ultra-modern, machined precision of *Interior # 2* 1964, with its working fan, large-faced clock and fluorescent light, is completed by the presence of a plastic 7-Up bottle, by a drape and a radio – stylized but accurately rendered substitutes fashioned in wood to the same scale as the original object – and by a window view in the form of a photographic poster of the Chicago skyline.

The transformation of European subject matter into American motifs was paralleled by Wesselmann's vigorous exploitation and reinterpretation of the formal attributes of recent American painting. The preference for huge surfaces that took the extremes of the paintings beyond the viewer's field of vision, for example, was already established in certain works by painters such as Jackson Pollock and Barnett Newman. The replacement of European notions of composition as a balancing of elements by an "all-over" composition, which distributed attention evenly across the entire surface of

the painting, was a characteristic of the work made in the late 1940s and 1950s not only by gestural painters such as Pollock and de Kooning but also by color-field painters such as Newman; in seeking to create a surface design by means of interlocking elements that gave equal weight to positive and negative shapes, and later through his use of the shaped canvas, Wesselmann consciously sought to translate this new attitude towards composition into a figurative mode.

Finally, the decisive rejection by American abstract painters of recessive, illusionistic space in favor of space that seemed to advance towards the spectator from the picture plane – a space, that is to say, at once more honest and more assertively active – finds typically literal expression in Wesselmann's art in his incorporation of real objects set into or in front of the surface. In *Still Life # 19* 1962, for example, he has included a three-dimensional commercial representation of a loaf of bread, bought from the bakery on a return visit to his native Cincinnati, as an emphatically intrusive entry into real space that takes to a logical conclusion the layering of objects implicit to the superimposition of the other collaged elements. During this visit he had gone around to local companies asking for whatever they had of this nature, including items from beer and soft drink displays. The three-dimensional loaf of bread, shown foreshortened to exaggerate its sense of physical presence, started him off on three-dimensionality.

"In art school I had been intimidated by my teacher, who insisted on a painting being flat. I once stuck a piece of collage on a painting and he came along and took it off, and he said, 'Now do it in paint, because you're a painter.' That attitude kind of stuck with me. Although I was in the meantime accumulating three-dimensional elements, because I sensed that I was going to be working in three dimensions. The three-dimensional loaf of bread, I believe, was the first time that I really broke into that, because I couldn't resist using it. So I broke down my barrier."

This form of assemblage was taken even further in works such as *Great American Nude # 48* 1963, in which real elements, such as a carpet and a table, contribute to the presentation of an entire coherent interior; since this is not an environment into which we are allowed to step, but only a representation of such a place, the presence of the actual objects serves to heighten our apprehension of the interpenetration of life and art through the inclusion, in such works as *Still Life # 38* 1964, of a working clock displaying the actual time and of a radio that can be tuned to receive and broadcast any of the local stations. *Still Life # 31* 1963 was one of several assemblages to incorporate a real black-and-white television, allowing a constantly flickering, moving image from the outside world to intrude into the otherwise enclosed world represented by the still life.

Under the influence of the American composer John Cage, other American artists, notably Robert Rauschenberg in his "combine-paintings", had made use of similar elements as a way of welcoming into their art chance effects and unexpected encounters from everyday experience. Whereas Rauschenberg, however, had written influentially in 1959 of his desire to work in the gap between art and life, Wesselmann sought in a far more deadpan way to bring art and life into a more direct confrontation. It is important, for instance, that the clocks tell the correct time, just as the radios and television sets are playing programs as they are emitted over the air waves. The work of art, as conceived by Wesselmann, does not simply comment on the world. Insistently present before us, it demonstrably exists in real time, as an integral part of our immediate environment.

By the mid-1960s Wesselmann had gravitated towards a greater expansiveness of scale and internal form alike, emptying out much of the detail from his pictures and in many cases conceiving his often larger-than-life images as broadly rendered fragments in an interior or exterior setting defined as succinctly as possible by colored shapes. However assertively present the motif – and it is difficult to ignore a representation of a female breast that is as large as we are – its effectiveness is couched, essentially, in a highly formal language that has much in common with developments in American abstract painting of the same period, notably hard-edge abstraction and color-field painting. It is through the crispness of outline created by the meeting of eloquent shapes, which themselves are given form as broad expanses of color, that the images are brought into being.

In order to make manifest the gradual evolution of Wesselmann's work as a series of responses to essentially formal problems, the works in this catalog have been grouped roughly chronologically according to approach rather than by subject matter. Taken in sequence, they reveal the

pictorial intelligence that has guided the artist over thirty years to continue inventing new strategies. The process is an essentially intuitive, not an intellectual, one; he proceeds from the visual evidence, not from theory. One important aspect of his development that is not adequately represented in this exhibition, for reasons of space, is his investigation of sculpture. This, too, is the end product of a long, slow investigation that was first set into motion in the early 1960s by his use of three-dimensional elements for his assemblages and by the slightly later use of shaped canvases and paintings composed of separate freestanding sections. Works such as *Still Life # 59* 1972 and *Still Life # 60* 1973 demonstrate his incipient interest in sculpture in the round, although the emphasis in these continued to be on the relationship of the parts to the whole when viewed from directly in front; that is to say, these are still conceived as paintings, in spite of their huge scale and of the physical presence accorded to each image as a separate object. It was in the late 1970s, with works such as *Maquette for Smoker (Sculpture)* and especially the *Tulip* installed in Seattle in 1978 that he finally gave form to images fully in the round.

A far more dramatic change occurred in Wesselmann's work in 1983, when he developed a new form – the metal works – to which he has devoted his attention almost exclusively ever since. In these works, which make up a substantial section of the exhibition, images conceived in the form of quick doodles or more elaborate drawings are enlarged in scale and cut out of sheets of aluminum or steel, either by hand or with the aid of lasers. The sense of them being brought into being almost by remote control has encouraged a tremendous outpouring of visual ideas, giving the metal works an extraordinary variety of form and construction, but their status within his prodution goes beyond the simple fact that they exist in such numbers and in so many permutations. For Wesselmann, the change represents nothing less than his reinvention of himself: "It was like turning a switch," he explains. "I'm totally different artist."

In the metal works Wesselmann has managed, apparently on a purely subconscious level, to synthesize the two impulses that had previously been at war in his art: the subjective and the objective. Having started out with an openly declared envy of Abstract Expressionism and the expressive, personal mark, he deliberately countered this emphasis on individuality through the use of collage, assemblage and anonymous surfaces. In the metal pieces he has miraculously found a way of preserving the subjective hand-made mark, as evidence of the intuitive process, while presenting it as an unyielding and impersonal surface fabricated with industrial precision. having previously found many ways of using ready-made objects, or of fashioning substitutes for existing things, he is now taking his own drawings – the most intimate side of all his art – as given images to be replicated in his most public visual statements. The process effectively enables Wesselmann to consider the products of his own hand with the same detachment that he had earlier accorded to found images, simply as motifs to be used.

The years spent in the studio, and the background of long periods of psychoanalysis, have led Wesselmann to act on an understanding of himself that is so deep-rooted he has not even had to think about it. Yet it seems to me that it is precisely this sense that he has been made whole that has been unleashed by the new form. Considering the fact that all his work now is based on the primacy of drawing, and that in order to produce a new piece he tends to make not just one but numerous sketches, it may at first seem curious that he admits even now to an intense dislike of the activity of drawing itself. Perhaps without realizing it, he set himself the challenge of developing an approach that would be entirely dependent on the activity that had given him most trouble, as a means of finally overcoming this resistance.

"Drawing was hard for me, I hated and despised drawing. However, I don't mind it so much now, I enjoy it more. I used to hate it because it was so difficult. I'd draw a nude and she was so beautiful as the model. It took me years to come to grips with the fact that the drawing had to be beautiful, and not the drawing of the model. That helped a bit. Now drawing is more interesting to me, because the way I draw with an increasingly fat brush and so on has become a little more adventurous, less painstaking. Drawing is a quick process for me. It either happens quickly and it's right, or it doesn't. In the early days, drawing, I'd slave over it, charcoal and pencil or whatever and erase, slave and erase, until I got it sort of right. I draw only when I have to; I like to paint so much that I can't stand to draw. So I don't draw for fun.

I don't draw for the exercise: I wish I did. I should, to keep my eye and hand better coordinated. I only draw when I'm really desperate and I need images, or when I want to try and explore something."

Such is his excitement still with the metal works, that it seems unlikely Wesselmann will ever return to paintings on canvas as his primary form of expression. Instead of laboring over a drawing as he used to, worried that it has to serve as a blueprint for a painting, he has left himself free to sketch in the most casual way imaginable, aware that it is the looseness and spontaneity of these scribbles and jottings that will yield the most vivacious results. The anxiety of creating an image out of nothing, which he had avoided in the past by employing ready-made motifs and objects, has now virtually disappeared because of the way that images are called up, almost absent-mindedly, by the activity of doodling. The enormous satisfaction he experiences in the whole process of bringing these works into being cannot fail to communicate itself to us. It is in this sense, rather than in the more superficial resemblances with the subject matter of his previous work, that Wesselmann has continued to expand on the characteristic high spirits of his art, even though the change of approach is so marked that it seems to him "almost like a split personality."

Asked whether he would describe himself as a hedonist, the British painter David Hockney remarked recently that as an artist he spent much more of his time abserving the hedonism of others than being a hedonist himself; if he was painting someone resting by the side of a swimming pool, it followed that he himself was busy working rather than resting. Living a quiet family life and spending a good eight hours a day, six days every week, in the studio, Wesselmann concedes that much the same could be said above him: "I wouldn't want to say that it *has* to be that way, but unfortunately that's the way it *is* with me." He describes his attitude and his routine with the same matter-of-factness that he demonstrates in his art: "I'm a studio-bound artist. I'm an obsessive worker, I work all the time. I have a hard time getting out of the studio for anything. All I really want to do is work. That's paly, for me." Perhaps this is not so unfortunate, after all, since it is through the making of his art that Wesselmann experiences his most intense enjoyment, and it is that sense of pleasure that he in turn conveys to us.

The Great American Nude

Jo-Anne Birnie Danzker

Reclined in splendour among patterned fabrics, resting beside her favourite fashion magazine, *Great American Nude #12* is magnificent in her absence. She has no identifiable features, no breasts, no legs, no mouth. Judy, who posed for the painting, wants to kiss her.[1] It is 1961 and Tom Wesselmann's *Great American Nude* has no personality.[2] He decides to collage a mouth, a photographed mouth, on the otherwise de-featured landscape of *Great American Nude #27.* Luscious sundaes stand in readiness beside her bed. Judy could kiss her if she wanted to.

It is a time of extroversion, optimism and fear. The Berlin Wall is erected; John F. Kennedy's Cubans fail to invade the Bay of Pigs. Marshall McLuhan declares in *The Gutenberg Galaxy* that the medium *is* the message. October 1962. The Cuban Missile Crisis threatens to expand into global war; the Sidney Janis Gallery in New York presents sixty *New Realists* from Britain, France, Italy, Sweden and the US. Tom Wesselmann is among them. The catalogue to the *New Realists* cites the French critic Pierre Restany:

> "In Europe, as well as in the United States, we are finding new directions in nature, for contemporary nature is mechanical, industrial and flooded with advertisements...
> The reality of everyday life has now become the factory and the city. Born under the twin signs of standardization and efficiency, extroversion is the rule of the new world."[3]

The Great American Nudes of Tom Wesselmann are standardized, efficient, extroverted – and flooded with advertisements. They *are* advertisements for a sexuality conducted on the surface of the bodies of women.

Royal Crown Cola

The *Great American Nudes* are now classified as Pop art. As early as 1961 Ivan Karp noted similarities between Wesselmann's work and that of fellow artist Roy Lichtenstein. They are "commonists", he is reported to have said, because of the use of common objects in their paintings.[4] Some of the common objects in Wesselmann's early Nudes are the Statue of Liberty, the American flag, Del Monte Fruit Cocktail, McCall's magazine, Coca Cola, Gordon's Gin and Marlboro cigarettes. Wesselmann describes these objects as having an "official reality", a potential for Super-Reality.[5] Like the Nudes – willing, pliable, extroverted – these objects are in a state of permanent readiness for consumption.

In 1964 Wesselmann gave his three metre by two metre *Great American Nude #53* an oversized mouth with parted lips and perfectly symmetrical pink nipples. The lips had been cut from a billboard advertisement for Royal Crown Cola.[6]

Wesselmann's combination of common objects, billboard advertising and large scale, lascivious Nudes gave Pop Art or Consumerist Realism its most memorable, and most problematic, icons of Woman.

The Woman Repertoire

The Woman Repertoire in the paintings of men, especially the Nude, has been under close scrutiny since the early 1970s. By both women and men. The renowned British critic, John Berger, argued in the BBC television series *Ways of Seeing* (1972) that the Nude is primarily about being seen naked by others and yet not being recognized for oneself.

> "Nudity is placed on display.... To be on display is to have the surface of one's own skin, the hairs of one's own body, turned into a disguise which, in that situation, can never be discarded."[7]

Berger insists that the principal protagonist in such paintings is not the female nude but the spectator in front of the picture, a spectator presumed to be male.

This notion of spectatorship, of male looking/female to-be-looked-at-ness, was at the centre of a controversy in art history, and art practice, which emerged in the seventies. Film and art historians, literary critics and psychoanalytic theorists began independently to question "the gendered and eroticized terrain of the modern city."[8] This was the terrain of Hollywood cinema, of mass media advertising, of Pop Art, of the Great American Nude.

By 1973 the Great American Nude was fractured and fetishized. A breast, a foot, a mouth nearly three metres large with a post-coital cigarette blowing smoke towards the spectator. Her objects of seduction and mask (lipstick, jewellery, nailpolish, sunglasses) were gigantized in shaped and standing paintings. Her fragmentation was complete.

Visual Pleasure

Such images are visually pleasing. The question is why, and to whom. The British film theorist, Laura Mulvey, attempted to answer this question in her landmark article, "Visual pleasure and the narrative cinema", which appeared in *Screen* in Autumn 1975. She directed our attention to psychoanalytic theory, Freud and Lacan, and to the central place of the image of woman in erotic pleasure.

"It is said that analysing pleasure destroys it. That is the intention of this article... daring to break with normal pleasurable expectations in order to conceive a new language of desire."[9]

Normal pleasure, Mulvey proposed, was expressed in the cinema (and, by extension, in painting) through the visual domination and voyeuristic consumption of images of women. But why? The explanation, according to Mulvey and numerous theorists who followed her, lies in the construction of male sexuality as described by Freud. Male desire, according to this theory, is fundamentally contradictory. Woman as threat, woman as fantasy.[10] Male desire is based on *scopophilia*, love of looking. As spectator, Man can manage his fear (and his fantasies) of Woman if her image – like that of the *Great American Nude* – remains passive, fragmented or dismembered, fetishized and above all silenced.[11] He can then search her body.

Roland Barthes described *A Lover's Discourse*.

"I am searching the other's body, he wrote. I am calm, attentive, as if I were confronted by a strange insect of which I am suddenly no longer afraid. Certain parts of the body are particularly appropriate to this observation, eyelashes, nails, roots of the hair, the incomplete objects. It is obvious I am in the process of fetishizing a corpse. If, however, the body I am scrutinizing happens to emerge from its inertia, if it begins doing something, my desire changes."[12]

Tom Wesselmann's *Great American Nudes* do not emerge from their inertia. They want to be searched, desired. They are.

Marco Livingstone describes *Smoker #9* (1973) with its gigantically enlarged mouth as

"a pair of kissable female lips, coated in a heavy layer of red lipstick, that promise to swallow us up into their seductive and cavernous opening."[13]

Does "us" include the female spectator? Does it include me? Am I rendered as passive, as silenced, by these images as the Great American Nude herself?

Looking in the First Person

Eduoard Manet's controversial *Olympia* (1863), with her "brazen" gaze created a stir at the Paris Salon where she was first exhibited. Olympia openly confronted the viewer with her sexuality. She looked back! The scandal, according to Griselda Pollock, was that women were among her spectators. This painting, she writes, was exhibited in

"the social territory of the bourgeoisie, the Salon, where viewing such an image is quite shocking because of the presence of wives, sisters and daughters. The understanding of the shock depends upon our restoration of the female spectator to her historical and social place."[14]

The female spectator of Olympia was affluent and privileged in an era in which female artists were

forbidden access to life classes. Laura Mulvey suggests that the only pleasure available to the female spectator (like the Nude, captive in the mechanisms of the male gaze) was, and is, a type of psychic transvestism![15]

A new generation of critics has challenged this orthodoxy. They argue that it *is* possible for a female viewer to have her own, distinctive visual pleasure but only when the woman offered as spectacle, the Nude, displays initiative, is fetish free, "refuses" conventional roles – and looks back![16] The *Great American Nude* cannot look back. She has no eyes. She does not refuse conventional roles, she embodies them.

High Voltaged Spectacle

The American artist, Barbara Kruger, describes New York's advertising wonder, Times Square, as
> "a high-voltaged spectacle which charmed its viewers with ridiculous suppositions made real: giant men blowing smoke rings, waterfalls traipsing along the tops of buildings, the A & P coffee sign which emitted the aroma of a fresh-brewed cup, the fifty-feet-high neon Miss Youthform who towered over us clad in nothing but a slip and my fave, the Kleenex sign which announced that 'You Can Blow Your Head Off'".[17]

Times Square and the *Great American Nude* are gargantuan spectacles of the same order. They flirt with our (non-gendered) senses of wonderment and pleasure.[18]

Are these oversized Nudes, like the advertising they mimic, "ridiculous suppositions made real"? Are they rendered harmless by their improbability? Or are these fragmented bodies "superlatives of the Other, synonyms for disruption and divison, employed in a form of reconfirmation of the self which is as patriarchal as it is violent."[19] Marco Livingstone:
> "Since the early 1970s, in the wake of the feminist movement, they have come to be interpreted by some commentators as signs of the objectification of women as mere objects of male sexual desire. At the time, however, they were clearly intended as radical expressions of the new openness and honesty about sexual matters that came to be associated with the 1960s."[20]

Wesselmann himself stated that his paintings grew out of a wish to deal visually with his own sexual preoccupations.[21] He described a direct link between his image-making and the long term psychoanalysis he has undergone.
> "[Analysis] made me healthy, so that I could do what I wanted to do and not have to retreat from it on some emotional level that I couldn't really comprehend."[22]

In almost no other series of painting is the problematic of the Nude and male desire so clearly articulated. As a "body" of work within the Pop Art or Consumerist Realism tradition, itself obsessed with commodity culture, the *Great American Nudes* represent the most extreme position of the male-female dialectic in modernism.
The artist's own writings provide invaluable insights into the nature of this dialectic.[23]

Works that Explode on the Wall

The *Great American Nudes,* he notes, are compositionally static, locked up tight, unable to breathe. They explode on the wall.[24] Aggression is created through an eroticism achieved by the depiction of shaved vaginas, spread legs and increased "realism". Facial features are consciously deleted to prevent the Nudes becoming Portraits:
> "Personality would interfere with the bluntness of the *fact* of the nude. When body features were included, they were those important to erotic simplification, like lips and nipples."[25]

Intimacy and personal relationship to the viewer are avoided. *The Great American Nude* herself abandons human relationships, becoming blunt and aggressive.[26] The larger her scale, the less erotic she becomes. "Body appendages"[27] are fetishized – especially feet and breasts – through large scale closeups. The mouth is emphasized as a sexual focus, open with the tongue out.[28] Flowers and fruit in proximity to the breast, navel or vagina underscore the importance of women to the "fertility" of Wesselmann's art.[29]
In some paintings the penis is introduced:

"It was… an incredibly vivid, electrifying image. In these works [I am] no longer the viewer but the subject, and they inevitably take on a bit of exhibitionism. In most of these works the erect penis is horizontal, so that it rather literally takes the place of the reclining nude as subject."[30]

Even between 1968 and 1976, when Wesselmann virtually stopped painting nudes, they are present in his Still Lifes.

"In *Still Life #60* the objects somewhat take the place of the nude since they imply her presence – they suggest a woman visiting [me] has placed her belongings on [my] table. The sunglasses could suggest the woman has arrived from outside, the necklace and ring could suggest undressing, the lipstick a beauty touch-up, and the open pack of matches suggest smoking, which could imply some degree of intimate relaxation in progress. In *Still Life #61,* [I am] the guest, placing the objects on the woman's table."[31]

Your Gaze is Devotional. Ours is Touristic.[32]

We are silent guests/voyeurs in Tom Wesselmann's fantasy world of anonymous sex. He shares the *Great American Nude* with us. He wants us to watch. He dismembers and enlarges her for our visual pleasure.

Roland Barthes dissected Balzac's tale *Sarrasine* into 561 fragments. In *L. The Reassembled Body* he writes of the female body as a division and dissemination of partial objects: leg, breast, shoulder, neck, hands. "Divided, anatomized, she is merely a kind of dictionary of fetish objects."

The *Great American Nude,* Fragmented Woman, is a dictionary of Woman as fetish.[33]

Unlike Judy, I don't want to kiss her.

Tom Wesselmann's devotional gaze cannot be shared by his female viewers, by me. A tourist in the landscape of his desire, I stand before the spectacle of the *Great American Nude* with (non-gendered) wonderment. But she and I, we are static, locked up tight, unable to breathe. We explode and our parts are propped up against a wall or on billboard platforms.

She, I, we are naked and anonymous. We abandon human relationships. We are passive, silenced, high voltaged spectacles. We are suppositions that are frighteningly real.

Your Gaze is Satiric.

Sigrun Paas argues in *Eva und die Zukunft* (Eve and the Future) that Tom Wesselmann's gaze is not devotional but satiric.[34] This would contradict Wesselmann himself.[35] Such a contradiction, however, seems to be inherent in the work of the Commonists or Pop artists of the 1960s and their love/hate relationship with commodity culture – and commodity sex.

Thomas Crow on the work of Pop artist, Andy Warhol:

"The debate over Warhol centers on whether or not his art fosters criticial or subversive apprehension of mass culture and the power of the image as commodity, succumbs in an innocent but telling way to that numbing power, or exploits it cynically and meretriciously."[36]

I do not believe that Tom Wesselmann exploited the image of woman as commodity either cynically or meretriciously. He *has* succumbed to the numbing power of that image in an innocent and telling way.

True Pop Art, according to Thomas Crow, was a "pulp-derived, bleakly monochrome vision that held, however tenuous the grip, to an all-but-buried tradition of truth-telling in American commercial culture."[37] Tom Wesselmann's superlatives of American commercial culture are bleakly multichrome. They tell a truth. Intentional or not, the *Great American Nudes* are a powerful critique of commodity sex, of alienation and the fractured, female body.

1 "The model, Judy, who had posed for this painting, exclaimed, on being shown her image, that she liked the picture so much that she felt inclined to kiss it, presumably in the spot where the mouth would be." Marco Livingstone, *Tom Wesselmann: A Retrospective Survey 1959–1992* (Shinjuku: Isetan Museum of Art, 1993), p. 22.

2 "A face on the nude became like a personality and changed the whole feel of the work, made it more like a portrait nude, and I didn't like that. So I used no features, from the beginning." Tom Wesselmann cited by Marco Livingstone, *ibid*, p. 22.

3 Cited in Chronology 1960–1969, *Vancouver: Art and Artists 1931–1983* (Vancouver: Vancouver Art Gallery, 1983), p. 192.

4 Tom Wesselmann, writing under the pseudonym Slim Stealingworth, *Tom Wesselmann* (New York: Abbeville Press Inc., 1980), p. 25.

5 *ibid*, p. 25.

6 Marco Livingstone, *op. cit.*, p. 22.

7 John Berger, *Ways of Seeing* (London, Middlesex: British Broadcasting Corporation, Penguin Books Ltd., 1972), p. 54.

8 Griselda Pollock, *Vision & Difference: Femininity, Feminism and the Histories of Art* (London: Routledge, 1988), p. 5.

9 Laura Mulvey, "Visual pleasure and the narrative cinema", *Screen,* 1975, 16 (3), 8.

10 "Sexuality is produced with desire, both predicated upon the patriachal price of acquiring gender and language – the repression of the mother and the dyadic unity of mother and child. The play of desire within and generated by looking at images is fundamentally contradictory, a) fearful of the knowledge of difference (woman as threat) and b) fantasizing its object (the image of woman as a fantasy of male desire, its sign)." Griselda Pollock, *op. cit.*, p. 147.

11 Griselda Pollock, *op. cit.*, p. 159.

12 Roland Barthes, *A Lover's Discourse: Fragments*. Translated by Richard Howard. (New York: Farrar, Straus and Giroux, Inc., 1978), p. 71. Originally published in French as *Fragments d'un discours amoureux* by Editions du Seuil, 1977.

13 Marco Livingstone, *op. cit.*, p. 78.

14 Griselda Pollock, *op. cit.*, p. 54.

15 Lorraine Gamman and Margaret Marshment, *The Female Gaze: Women as Viewers of Popular Culture* (Seattle: The Real Comet Press, 1989), p. 51.

16 *ibid.*

17 Barbara Kruger, "An Unsightly Site" (1988), published in *Remote Control: Power, Cultures, and the World of Appearances* (Cambridge, Mass.: MIT Press, 1993), p. 17.

18 *ibid,* p. 17.

19 Susanne Mayer, "Traum von Tod der Frau", *Die Zeit,* No. 5, 28. Januar 1994, p. 30. A review of Elisabeth Bronfen's book, *Nur über ihre Leiche* (München: Verlag Antje Kunstmann, 1994).

20 Marco Livingstone, *op. cit.*, p. 22.

21 Tom Wesselmann, *op. cit.*, p. 13.

22 Cited by Marco Livingstone, *op. cit.*, p. 22.

23 Most critics, whatever their political or sexual affiliation, agree that this dialectic began to take its present shape in the 1850s in France and in Pre-Rephaelite Britain. Its stereotypes were consolidated in early Hollywood cinema and in the advertising/mass media universe which 150 years later dominates our visual culture. In the last twenty years of this century, a generation of artists has emerged which has challenged the orthodoxies of visual representation of women. The representation of Woman, her fragmentation and fetishization in art, film and the mass media, became the subject of their art.

24 Tom Wesselmann, *op. cit.*, p. 15, 17.

25 *ibid,* p. 24.

26 *ibid,* p. 33.

27 *ibid,* p. 56.

28 *ibid,* p. 52.

29 *ibid,* p. 44.

30 *ibid,* p. 56. As Wesselmann is writing under a pseudonym, he has used the third person. I have changed this quote to first person.

31 *ibid,* p. 68.

32 Barbara Kruger, *op. cit.* Catalogue statement, *documenta 7,* Kassel, 1982, p. 216.

33 Roland Barthes, *S/Z,* translated by Richard Miller (New York: Farrar, Straus and Giroux, 1974), p. 112. Originally published in French as *S/Z* in 1970 by Editions du Seuil, Paris.

34 Sigrun Paas, *Großer Amerikanischer Akt Nr. 57,* in Werner Hofmann, *Eva und die Zukunft: Das Bild der Frau seit der Französischen Revolution* (München/Hamburg: Prestel-Verlag/Hamburger Kunsthalle, 1986), p. 137.

35 "he is quick to… deny that he was either celebrating or satirizing the way of life they (the Great American Nudes) represented." Marco Livingstone, *op. cit.*, p. 23.

36 Thomas Crow, "Saturday Disasters: Trace and Reference in Early Warhol", Serge Guilbaut (ed.), *Reconstructing Modernism: Art in New York, Paris, and Montreal 1945–1964* (Cambridge, Mass.: MIT Press, 1990), p. 311.

37 *ibid,* p. 324.

Metal Works, Cut-Out Drawings, 3-D-Paintings

Tilman Osterwold

The Presentation of Images

The image – that untranslatable English term – reveals the tendencies that unfold within the web of relationships between trivial and artistic fields of effect. It is the everyday "pictures" – furnishings, constellations, psychologies – that are presented in still-life-like concentration as images of art; a slice of life rendered motionless, captured in the perspective of the motif; a limited version of the ordinary held in the "bonds of art". There, the routinely sensational is subject to new rules, to the personal jurisprudence of artistic motivation, to a complex view of hierarchical relationships, to indirect participation through imposed "voyeurism". Wesselmann's "rules of art" present the deceptive "images" as cool, capable of abstraction, sterile, surreal, artificial, dynamic, fractured, typified – as the professional synthesis of an unconventional, self-determined process of image-production and focal presentation.

Typically American

American life is reflected in American art, a regionalism rooted in the tradition of the 100-year history of trivial "myths" in U.S. art since the time of the Ash Can School around 1900. In his milieu still lifes of the 1960s, Wesselmann displays the boring, eroticized ambiance and its banal-insistent, stimulating trappings much like a sloppily constructed doll's house. In the *Metal Works* of the 1980s we find the trenchant relics of those relationships, the lines and vectors of an everyday seismogram, the cartographic features of a lived-out lifestyle in the austere, uncamouflaged tradition of Pop Art. Hasty, sketchlike, calculated, constructed, metallic and colorful – the "images" are combined, the "pictures" put together. Wesselmann presents landscapes, street scenes, views of houses and gardens – all of the idyllic motifs that made up the pictorial repertoire of the traditionalistic, idealizing painting of earlier centuries, which also found a home in America – with typically American regionalist casualness and emphasis in his *Steel Landscapes.* He highlights elements that tend to appear unremarkable within the "framework" of the familiar, customary approach to the motif: telephone wires, the edges of roads, traffic signs, construction joints, shadows. The trend towards the objectification of relationships goes beyond concepts of form. The reflection, the creative mirror, is shown as a fact, as a physical object, as a three-dimensional montage. The insistent insists, the general is generalized, the trivial trivializes; what is American gets in its own way, American-style. Fact is object, feeling, art, opinion. "It" is the American epitome of an attitude.

Technique

In the *Metal Works* the soft surroundings are turned into metal. The lines, the particular artistic style that serves to characterize the "facts" of the motif, are transferred – translated – to metal plates (usually aluminum) from sketches and cardboard models; smaller sketchlike works are done by hand, larger-scale objects are produced using industrial, mechanical processes (laser cutting). By imparting color to the metal, a time-consuming process Wesselmann performs himself, he gives the metallic objects and

materials the effect of transparency. This transparency relates to both form and content. The formal tricks (the childlike stereotyped cut-outs, the infantile fret-saw patterns remain as mementos) appear masterful and harmless – reliefs fashioned in multiple layers in which the technical gestures are superficially disguised. "Boredom" typifies itself in the background, the "scribbled" lines, the maquettes – familiar from illustrations and advertising or architectural sketches – articulate themselves dynamically, the "hand-drawn" networks constructively. The overall pattern tends away from seeming triviality towards an ambivalent spectrum of fascination and melancholy, fantasy and reality, acuteness and inconsistency, illusion and banality, precision and vagueness, system and carelessness, reality and appearance.

Perspective and Composition

These aspects are evidence of formative ambition; they point the way to an artistic location within the history of contemporary art, clarify or mystify formal positions (as reflections, reflexes of substantive points of view). It is the perspective(s) that place each set of surroundings into the "right" situation, in which what is familiar and correct appears disturbingly robbed of its static properties, its function, its stability, its "correctness". The context of the everyday is transposed into a free-floating excursion: ideas, memories, yearnings and home-made behavioral norms grow together to form an atmosphere which, despite its optical stringency, remains inscrutable in terms of form and content. The white wall, the *tabula rasa* on which the colored metal pictorial reliefs are mounted, functions as a vacuum in which concrete, factual aspects of a constellation consisting of object, human viewer, space and surroundings return or fall or collapse into a weightless state of spatial disorientation before eventually casting back its shadows. The lines conceive a renewed mystification of compositorial experiences. Wesselmann restructures the "framework" of "classical" principles of composition, in which height and width, vertical and horizontal axes and their diagonal intersections classify spatial and pictorial order as well as levels of perspective in aesthetic terms according to their content function. Spatially, they appear to emphasize surface; their surface levels seem three-dimensional; the interconnected co-ordinates appear as impenetrable networks, the ornamental connecting patterns as irritations. The simplicity of forms and associations of objective, artistic, mental and fictional products slips into endlessness and unfathomable depths. The consequence is dematerialization, the elimination of boundaries between the everyday and the figurative image. Its products are complex levels of effect, tensions, fractures and unexpected atmospheres.

Images in Pictures

The equality of pictorial elements – objects, symbols, lines – is an essential formal criterion in the *Metal Works*. Wesselmann's pictorial structure is conditioned by an ornamental affinity in which all elements of the picture appear interconnected, woven together. The ingredients crystallize to form images in the picture as a whole. Illustrative, characteristic lines demand a dynamic form of seeing; their elasticity provokes explosive activity in the picture; the decorative fillers take on an intense, abstract formal volatility. Images, "works of art" and motif details become pictorial unities and grow together with the entire composition to form a pictorial matrix. Here, the quintessence, the character of the still life takes shape: content in formal autonomy, where the individual part, the independent meaning becomes a cell within larger total view. Wesselmann's "facts" are both objective and abstract. The window motif bundles this relationship between internal and external spatial correspondence. The "picture on the wall" represents the component of household furnishings that contributes ambivalently to enter-tainment, to decoration and to an enlightening assurance of artistic ambition. The "picture on the wall" is a metaphor for the artistic and cultural hierarchies Wesselmann's work is devoted to qualifying. In the *Metal Works,* the "painting" – itself untranslatable – designates a cultural position which has to a significant extent estranged itself from itself, or perhaps rediscovered itself, under the influence of elements of irritation and forms of wear and tear (and of "art about art").

After Matisse

Contours to empty spaces (outline shapes); light to shadow; light to heavy (light metal to painting); form to object; sign to symbol (of daily life); attitudes to gestures; casualness to volatility; decoration to construction; calculation to (moderate) spontaneity; clarity to overabundances; space to surface; image to images; art to arts; timelessness to modernity; present to history; everyday to Sunday; gray to colorful: equivalents and balances, ambivalences and oppositions, multi-dimensional constellations define an ornamental pictorial structure. Objects, lines, surfaces, spaces, segments and elements are stylized on the surface; they appear transparent, as in a highly contoured diapositive. Color tones suddenly fracture and retreat into grays. In the work entitled *Drawing for Still Life with Two Matisses* (1990), the figure and the picture of Matisse are woven together with the total constellation of entertaining, banal-trivial accessories and their linear hatching fillers; the empty forms, the ornamental contours and the decorative allusions combine to produce a color-stream of gestures that encompasses the entire picture. As early as 1959 and 1960 Wesselmann painted color sketches in the style of Matisse, in which these formative relationships are suggested. Matisse's artistic presence and currency continually bring up the question of the relativity of the dimensions. Wesselmann's principle of composition propels the *Metal Works* into an obscure state of balance between the levels of surface and space, an abstract-objective congruence between content and form in which lines turn abruptly to jut from the wall or insinuate themselves into frames, lending dynamics to the trivial through the extended play of gestures. The essential formative characteristics of the American artist are comparable to abstract expressions that leave aesthetic functions open. The decorative-ornamental joins in non-competitive interplay with free linear expressions and allusions to physical objects (comparable in a certain sense to Frank Stella's explosive color reliefs and their defiance of spatial constraints). The scene of the picture serves as the stage for performing shapes that play a substantive role. Wesselmann clarifies – or mystifies – his relationship to art and cultural history, to contemporary and popular culture by means of pictorial reminiscences within the context of the household. Amidst the still-life world of everyday metaphors we find artists from Cézanne to Mondrian, Warhol to Lichtenstein, Léger to Matisse behaving like restrained bundles of energy whose artistic systems face yet another challenge, this time from the world of decorative manifestations. As rediscovered and artistically reproducible, re-usable, reassessable and metamorphosed components of a culture of entertainment and a new, regained culture of art, they appear as "windows" between the externalized internal world of art and its levels of reference and response to the outside world.

Pop Art and the Europeans

Meinrad Maria Grewenig

Thirty years after its breakthrough, Pop Art has become a central theme in the European art world of the 1990s. Pop Artists (still) attract great numbers of visitors. The subject of Pop Art has neither been exhaustively examined nor, certainly, put to rest. Recent exhibitions[1] and studies[2] in particular have reassessed the phenomenon of Pop Art. Interest in the "classical" figures of American Pop Art – Robert Rauschenberg, Roy Lichtenstein, Andy Warhol[3], Tom Wesselmann[4] and others – has been fueled in Europe by decades of uninterrupted public debate about the value of art and its presentation in museums. This discussion has been fostered by artists whose art is rooted in concepts of an artistic approach to reality shaped during the 1960s and who belong to the extended circle of Pop Artists themselves. In this context America and Europe have always been closely related and interdependent.

The twenty-year public discussion surrounding Christo's veiling of the Berlin Reichstag, finally made possible in 1994 through a resolution of the German Bundestag, is a prominent recent example of this debate. We also witness intense interest in and re-evaluation of artists whose concepts of art were related to Pop Art during the 1960s, many of whom worked on the fringe of that movement, but who, like Sigmar Polke[5] or Gerhard Richter, have gained ground during the past few decades and now occupy leading positions.[6] The aggressive triviality, incisive irony and shocking quality of their works has served to maintain keen interest in the trivial aspects of Pop Art reality within the discussion of the concepts of this kind of art during the past thirty years – particularly at times when that art seemed in danger of being forgotten. Sigmar Polke, Gerhard Richter and Konrad Fischer-Lueg established the theoretical foundation for their art in their joint manifest, "Capitalist Realism", published in 1963. The use of elements from the everyday world and its patterns or the allusion to images from trivial culture or to advertising language were seen as a deliberate turn away from the "non-representational forms" of the 1950s *Informel* movement and its emphasis upon gesture and material. The tendency represented by these artists was regarded at times as an independent German variant of Pop Art.[7] Their works were shown in Paris at the Iris Clert and Ileana Sonnabend galleries as those of "German Pop Artists" in 1963. Chronologically, they originated after the first phase of American Pop Art, *Nouveau Realisme* and Beuys's Fluxus movement.

Thirty years later, near the end of the 20th century, these artists enjoy great acclaim. Thomas Krens, Director of the Guggenheim Museum in New York, sees Sigmar Polke's work *Paganini* as a guiding principle in his reflections on "German Sculpture: Paradox and Paradigm in late 20th-century Art".[8] Karl Ruhrberg, a prominent observer of contemporary art, places Sigmar Polke's artistic position as the end-point at the conclusion of his thoughts on painting in our century. Under the title "Befragung der Hoch- und Trivialkultur" (Questioning High and Trivial Culture), Ruhrberg writes: "The most flexible, the most restless, the wittiest and at the same time the most enigmatic of young contemporary artists, not only in Germany but in the international scene as a whole, is certainly Sigmar Polke. The intelligence and stubborn intensity of his artistic mentality, which takes nothing for granted, neither forms nor materials, are unrivaled at this time".[9] Gerhard Richter's work has been extensively honored, receiving great international acclaim not only in the 1994 retrospective exhibition shown at the Musée d'Art Moderne de la Ville de Paris, the Kunst- und Ausstellungshalle der Bundesrepublik Deutschland in Bonn, the Moderna Muset in Stockholm and the Museo Nacional Centro de Arte Reina Sofia in Madrid.[10] The large-scale Wolf Vostell retrospective presented at six German museums in 1992 brought the work of an artist to the foreground who, particularly in his early "paintings" was even somewhat in advance of the American Pop Art movement.[11]

In the last decade of our century the 1960s are once again a major focus of attention. The significance of the period, both in terms of approaches to a perception of the realities of this world and

with regard to conceptual changes – in the museum field, for example – cannot be overestimated. Slogans like "culture for all" or "life and art" play a dominant role in this debate. Today, Pop Art seems more current than ever. Its concepts are more than mere signets of the 1950s; they provide both the key and the perspective for an understanding of art at the end of the 20th century.

Alongside Andy Warhol, Robert Rauschenberg and Roy Lichtenstein, Tom Wesselmann must be regarded as one of the outstanding representatives of American Pop Art. Through the efforts of the Sammlung Ludwig in Cologne his *Interiors* (see plate 23) and *Great American Nude* (see plate 11) were brought to view and to public awareness in Europe early on. *Interior #2,* 1964 (plate 2), combines painting, household furnishings, a clock and a light source. This "still life" of an everyday world presents a particular situation and in doing so joins together different threads of time and levels of reality. The large-format work, whose effect is to totalize an aspect of the everyday, immediately opens up a view of Wesselmann's concept of art. The combination of different zones of reality has its conceptual roots in the "papiers collés" of Cubism and the collages of a Kurt Schwitters from the 1920s. In these works, various fragments of reality are combined for the first time in such a way that a new pictorial reality emerges. The use of found objects in Wesselmann's work is also reminiscent of the "ready-mades" of Marcel Duchamp. The stringent compositorial structure immediately puts one in mind of the seemingly abstract interior spaces of Henry Matisse (*Porte-fenêtre à Collioure,* of 1914, for example), in which a balance of pictorial elements is achieved between the objective designation of a pictorial entity and the formation of an articulate compositorial segment of the picture. In these interiors Matisse uses the color black for the first time to emphasize light and depth. In this respect, Tom Wesselmann takes up a thread spun in Henri Matisse's art – one that was unfamiliar to Europeans, as all of these pictures were in the U.S. This compositorial impulse in the work of Matisse inspired Marc Rothko and Barnett Newman during the 1950s to paint their strictly abstract compositions. Tom Wesselmann's reception of Matisse is extensive, encompassing even many of the same motifs. The motif in *The Great American Nude* alludes to the subject of the reclining woman, as in *Nu Rose* of 1935, for instance, which now hangs in the Baltimore Museum of Art.[12] Tom Wesselmann's develops an inner dialogue with Henri Matisse in his work, and it continues into the *Cut-Outs* of the 1980s. Not only does Wesselmann forge a link to Matisse, he takes the French artist's experiments with pictorial surfaces and existing space a step further, producing highly complex spatial situations incorporating oversized panoramas of the everyday world. These works are objects, on the one hand, and large-format pictorial situations on the other. Tom Wassermann himself finds the term Pop Art strange and inappropriate. "I dislike labels in general and Pop in particular, especially because it overemphasizes the material used. There does seem to be a tendency to use similar materials and images, but the different ways they are used denies any kind of group intention."[13]

Of all of America's Pop Artists it is Tom Wassermann who relies most on European pictorial traditions. In the design of his large figurative situations he has continued to develop concepts of that European tradition even in his most recent works. In contrast, European artists – among them Christo, Polke and Richter – have developed strategies that ultimately hollow out, expand or even devaluate the European pictorial concept.

In the mid-1960s, American poster-style Pop Art was on everyone's mind in Europe. The award of the first prize to the American artist Robert Rauschenberg at the 1964 Venice Biennale impressively documents both Pop Art's first momentous achievement and the first sign of the ascendancy of the American art scene. And with that the worldwide breakthrough of a new approach to art oriented towards what was real and factual in the world was accomplished.

The origins of this movement are actually to be found in England, in the collages created by Eduardo Paolozzi and Richard Hamilton during the 1950s. Originally, this new type of art was scarcely noticed. In 1960 Pierre Restany and a number of his friends founded the *Nouveau Réalistes* in Paris. "In my opinion, this was the main difference between Paris and New York. Ordinarily, the Europeans, because they were more consistent in their logic, simpler and more precise in their presentation and more direct in their use of objects, remain genuine 'new realists' in every sense of the word. The so-called American 'neo-Dadaists', romantics at heart, but intellectually rather cubistic and baroque in tone – and aside from that more susceptible to the temptations of Surrealism – were concerned with creating

a modern variation of object-fetishism..."[14] In 1962 the newly opened Galerie Ileana Sonnabend in Paris presented American Pop Artists in Europe. At this time, the gaze of the European art world was still focused on Paris. In the same year, New York's Sidney Janis Gallery was still presenting Pop Art under the title of "New Realists". Represented in the joint exhibition were Jim Dine, Robert Indiana, Roy Lichtenstein, Claes Oldenburg, James Rosenquist, Georg Segal, Wayne Thiebaud, Andy Warhol and Tom Wesselman from the U.S.; Peter Blake, John Latham and Peter Phillips from England; Arman, Enrico Bay, Christo, Oyvind Fahlström, Tano Festa, Raymond Hains, Yves Klein, Martial Ryasse, Minimo Rotella, Marioa Schifano, Daniel Spoerri, Jean Tinguely and others from Europe. The participating *Nouveau Réalistes* were regarded as an autonomous phenomenon. Critics, gallery owners and even the artists themselves defined the characteristic features of their art in contrast to those of Europeans.

The award of the first prize at the Venice Biennale to Robert Rauschenberg led to a reassessment of existing relationships. In his preface to the American catalogue for the Biennale, Alan R. Samson asserted provokingly that "the center of the art world has shifted from Paris to New York". Young artists with strong affinities to Pop Art made New York their home. Arman and Christo eventually settled there permanently.

At the same time, a very strong interest in the new American art took root in Europe. The most valuable and extensive collection of American Pop Art in the world was established in Germany. Peter and Irene Ludwig were interested in "how people lived in the 1960s, what they consumed, how they spent their time, what their lives were about". They purchased artworks in New York and at the "documenta" in Kassel. Karl Ströher and the Italian Count Panza di Biumo also acquired major collections.

America's Pop Art and the realist tendencies evident in Europe during the 1960s were intended as a renewal in opposition to 1950s abstract painting, to Action Painting, to *Tachisme* and the *Informel* school. In conceptual terms, they were concerned with what is factual in the world. In terms of a pictorial concept their paths diverged.

1 See for example the exhibition "The Pop Art Show" at the Royal Academy of Art, London 1991 and at Museum Ludwig, Cologne, 1992. Cf. exhibition catalogue, Marco Livingstone (ed.), *Pop Art* (London: 1991; Munich: 1992).

2 Cf. Tilman Osterwald, *Pop Art* (Cologne: 1992).

3 Concern with the fringe areas of Pop Artists activities is also a part of this specific interest. In the case of Andy Warhol, for instance, this includes his photography. See also Karl Steinorth and Thomas Buchsteiner (eds.), *Andy Warhol, Social Disease Photographs 76–79,* catalogue for the exhibition tour 1992–1994 (Ostfildern near Stuttgart: 1992); or Meinrad Maria Grewenig, *Andy Warhol Celebrities,* catalogue for the exhibition "Andy Warhol Celebrities and Factory Life" at the Historisches Museum der Pfalz, Speyer, 1993 (Speyer: Historisches Museum der Pfalz, 1993).

4 This retrospective is also a central focus of newly awakened interest in the concepts of this school of art.

5 See also Meinrad Maria Grewenig, *Sigmar Polke Dreiteiliges Genähtes 1988* (Saarbrücken: 1990).

6 Sigmar Polke, for instance, participated in Documenta 6 and 7 in Kassel in 1977 and 1982; he represented the Federal Republic of Germany at the 42nd Biennale in Venice, where he was awarded the "Golden Lion". See Dierk Stemmler (ed. and exhibition commissioner), *Sigmar Polke Athanor il Padiglione, XLII Biennale die Venezia 1956* (Düsseldorf: 1986) and Dierk Stemmler, "Pavillon BRD Sigmar Polke" in *Kunstforum International,* Vol. 85, October 86, pp. 182–187.

7 Cf. Ludy R. Lippard, *Pop Art* (Munich/Zurich: 1969), pp. 209 ff.

8 In Thomas Krens, Michael Goron, Joseph Thompson (eds.), Neue Figuration, *Deutsche Malerei 1960–88* (Munich: 1989), pp. 9–19.

9 Karl Ruhrberg, *Die Malerei unseres Jahrhunderts* (Düsseldorf/Vienna/New York: 1987), p. 454.

10 On Gerhard Richter see the three-volume catalogue of the Kunst- und Ausstellungshalle der Bundesrepublik Deutschland (Ostfildern near Stuttgart: 1993).

11 Cf. Rolf Wedewer (ed.), *Vostell* (Heidelberg: 1992).

12 Martina Ward examines this phenomenon in her dissertation entitled *Tom Wesselmann: Studien zur Matisse-Rezeption in Amerika* (Hamburg: 1992).

13 In G. R. Swenson (Interviews), "What is Pop Art?" Part II, *ARTnews* LXII/10, February 1964, p. 64, cited from Marco Livingstone, *op. cit.,* p. 57.

14 Pierre Restany, "Le réaliste dépasse la fiction" in *Le Nouveau Réalisme à Paris et New York,* catalogue preface (Paris: Galerie Rive Droit, 1961), cited from Marco Livingstone (ed.), *op. cit.,* p. 230.

Biography

1931	born February 23, 1931 in Cincinnati, Ohio
1945–1951	attends Hiram College in Ohio
1951	attends the University of Cincinnati; studies psychology
1952–1954	studies interrupted when he was drafted into the U.S. Army for the Korean War; frustrated with his regimented existence, Wesselmann begins to draw satirical cartoons
1954–1956	continues studies at the University of Cincinnati and at the same time begins taking courses at the Art Academy of Cincinnati
1956	moves to New York City
1956–1959	studies under Nicolas Marsicano at the Cooper Union School for Arts and Architecture in New York; to earn a living, Wesselmann teaches in a Brooklyn high school and works as a cartoonist for several newspapers and magazines
1959	completes a series of small collages that are regarded as precursors for his later series of large works like *Great American Nudes, Bathtubs,* and *Still Lifes*
1960	develops his first nudes from the early collages

1961 first exhibition in the Tanger Gallery in New York; completes the first work in his *Great American Nudes*; begins to work in larger formats and maintains his deliberately explicit, sometimes shocking, eroticism

1962 participates in the collective exhibition "The New Realists" in the Sidney Janis Gallery and thus launches his career as an international artist; during the year, he completes the first assemblages entitled *Still Life*

1963 marries his girlfreind, fellow student, and most important model, Claire Selley; begins his *Bathtub* series in during this year

1966 first solo exhibition in the Sidney Janis Gallery; more than a dozen follow

1964–1978 begins further series like *Bedroom Paintings, Seascapes,* and *Smokers*; he continues these projects well into the early eighties

1980 publishes, under the pseudonym of Slim Stealingworth, a literary account of his artistic development

1983 completes his first *Metal Works,* works based on his sketches and drawing that are currently the focus of his artistic interest

1994–1996 first European exhibition tour; Brussels, Berlin, Paris, Rotterdam, Madrid, Barcelona, and others show "Tom Wesselmann – A retrospective survey"

Large Early Collages

Plates 1, 2

This group of works done in the late 1950s marks Tom Wesselmann's departure from the abstract-expressionist painting that had previously influenced him. While his striving for intensity and power of expression remain clearly recognizable, Tom Wesselmann now turns to a different stylistic mode of contemporary art: in the tradition of the Dadaists he integrates waste products of everyday consumption into his pictures – canceled fare tickets, torn packaging, useless old note slips – all references to lived reality. The individual elements of his pictures are combined in an apparently free interplay of forms and colors to form a composition that expresses the spontaneity of gesture.

Small Early Collages

Plates 3–10

Tom Wesselmann includes figurative elements in the small early collages completed during the early 1960s. In doing so, he relies upon a favorite artistic genre – the female nude. He presents interiors that offer the viewer a glance at a personal world quite distinct and apart from the outside world. Wesselmann confronts his figures, whose poses are reminiscent of the odalisques of classical modernism, with relics of everyday American life, e.g. with postcards of big American cities. In this way, he brings together achievements of European culture with motifs from contemporary American experience.

Collage Paintings

Plates 11–16

Under the influence of the insistent presence of oversized billboards of urban America, Tom Wesselmann moves to artistic creation on a large scale. In doing so, he is compelled to sacrifice, for the most part, elements of collage in favor of painting, since there are very few materials that can be integrated harmoniously into his large-format compositions. The increasingly poster-like imagery is a reflection of the influence of advertising on his creative work. The female nude continues to play an important role. Making use of the iconography of advertising images, Tom Wesselmann no longer relies on historical traditions in art.

Assemblages

Plate 17–23

In his assemblages, Tom Wesselmann expands his surface-based collages to include three-dimensional objects. He incorporates mass-produced products, usually household objects such as towel holders, clocks, kitchen shelves or fans, into his compositions. Analogous to depictions from the world of advertising and design, he presents interiors, primarily bathrooms and kitchens, typical of middle-class American households. The sterile ambiance of these rooms and the highly polished metal and ceramic surfaces are quite in keeping with Wesselmann's intention to achieve a smooth and impersonal language of images – a tendency that is also revealed in the sketchy, impersonal figures that populate this fictional reality.

Plastics

Plates 24–27

In his plastic works, Tom Wesselmann once again takes up the methods and formal language of advertising. He uses this material for a short time during the mid-1960s, drawing plastic foil into the desired pictorial form and then painting it. In this way his *Plastics* take on the synthetic quality of familiar industrially manufactured products such as the gaudily colored filling station signs popular at the time.

Shaped and Standing Paintings

Plates 28–32

In his *Shaped Paintings,* Tom Wesselman bids farewell to the conventional use of canvas, leaving behind not only its two-dimensionality, but the dictates of rectangular form as well. In a reversal of traditional methods, the form of the motif now determines the form of the canvas. The same period witnessed the completion of his *Standing Paintings.* In these works the boundaries between painting and sculpture have been eliminated; as three-dimensional wall panels they remain designed primarily with a frontal view in mind. Their poster-like coloration, billboard-ad style and oversized pictorial formats lend these compositions an unusual visual presence.

Drop Outs

Plates 33, 34

Tom Wesselmann refers to yet another group of his works as *Drop Outs.* The literal meaning of "drop out" refers to a process of removing or cutting out. Unlike the *Shaped Paintings,* the *Drop Outs* contain fragments of the female body as negative forms. Although the shape of the canvas is pre-determined at the very beginning of the creative process, the pictures give the impression that the body contours have been cut out at some later point. The oversized body parts seem robbed of their connotative significance, their symbolic meaning, as if they had been created exclusively for the sake of the perspective-bound illusion of a "see-through" effect.

Bedroom Paintings

Plates 35–45

In his *Bedroom Paintings,* Tom Wesselmann fragments the female body and depicts only isolated body parts. Although the pictures reveal nothing of sexual intimacy, they nevertheless leave room for erotic associations. Not only is the viewer compelled to assume the role of a voyeur, he is also shown to be one. The disturbing insistence and immediacy of these oversized works is ameliorated by the cool, perfectionist imagery.

Smokers

Plates 46–48

The perfectly lipsticked mouth, the lascivious open lips and the rising smoke of a cigarette are reminiscent of a detail shot in a film. Compared to his earlier works, Tom Wesselmann has gone yet another step further in *Smokers,* in which he creates gigantically enlarged advertising clichés whose expressive power derives from the calculated use of erotic symbols such as invitingly open lips and long (red) fingernails.

Metal Works

Plates 49–72

With his earliest work in metal, completed in 1983, Tom Wesselmann began the most productive phase of his career. Most of these works are based upon sketches made in apparent haste: landscapes, still lifes, nudes. The handmade drawings were transferred manually or electronically onto aluminum or steel plates and the shapes cut out with extreme precision using a laser beam. All of the important elements found in his early works are united here. The *Metal Works* combine traditional motifs with hyper-modern production techniques.

Studies and Drawings

Plates 73–95

In his studies and drawings Tom Wesselmann makes use of a wide variety of techniques – pencil, colored pencil, ink, acrylic and charcoal. They represent the basic foundation stones of his entire artistic work, existing not only as drafts but also becoming, in some cases, independent works of art in their own right. Above all, however, they served as original studies for his *Metal Works.*

Sculptures

Plates 96–98

Large Early Collages

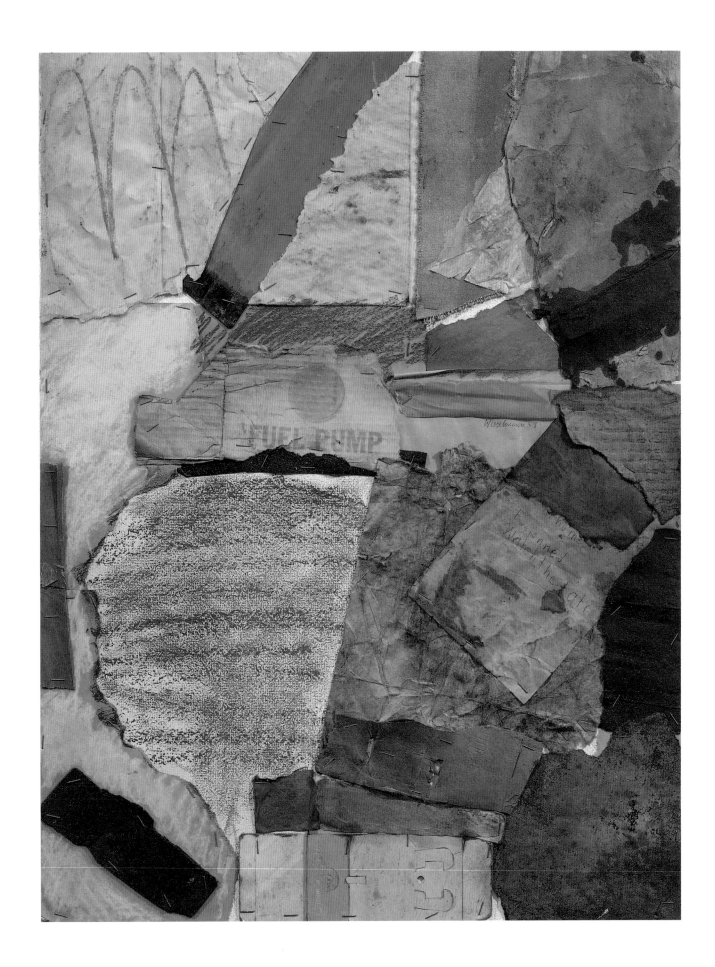

1 1959
Green Camp Pond

Pastel, collage and staples on composition board,
80.6 x 60.3 cm

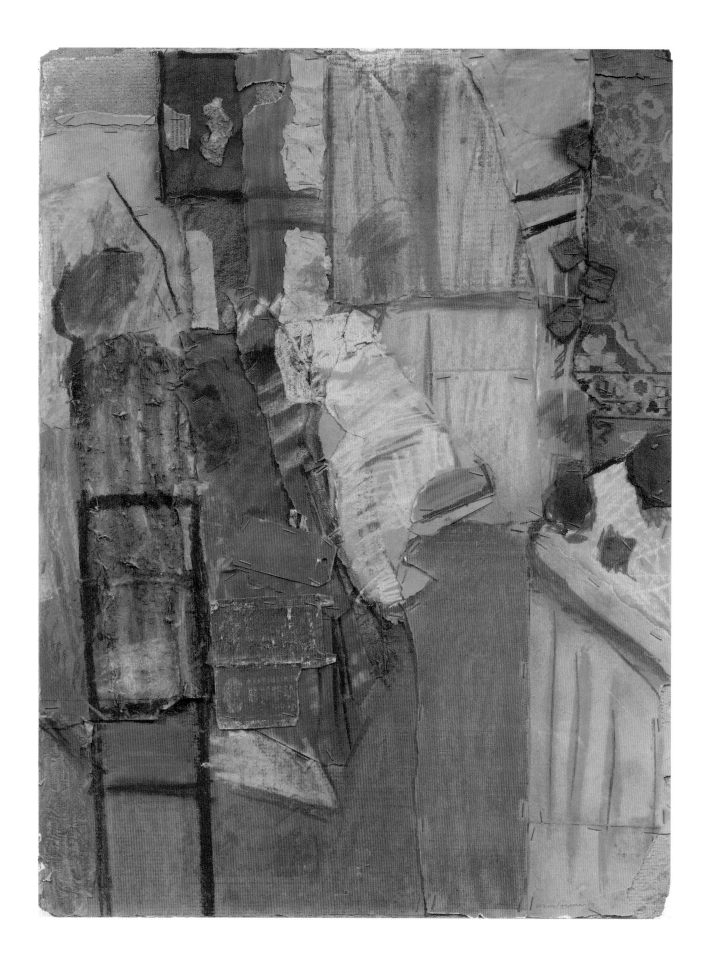

2 ¹⁹⁵⁹
After Matisse

Pastel, collage and staples on composition board,
81.3 x 61 cm

Small Early Collages

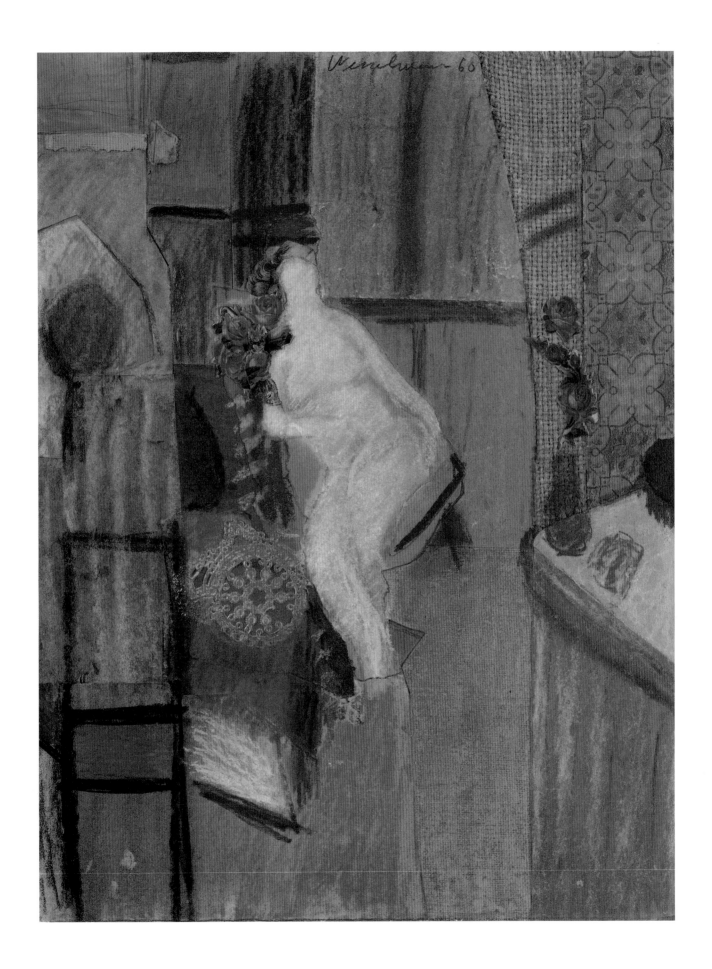

3 1960
After Matisse
Pastel and collage on board,
38.1 x 29.5 cm

4 1959
Portrait Collage # 1
Pencil, pastel, collage and staples on board,
24.1x27.9 cm

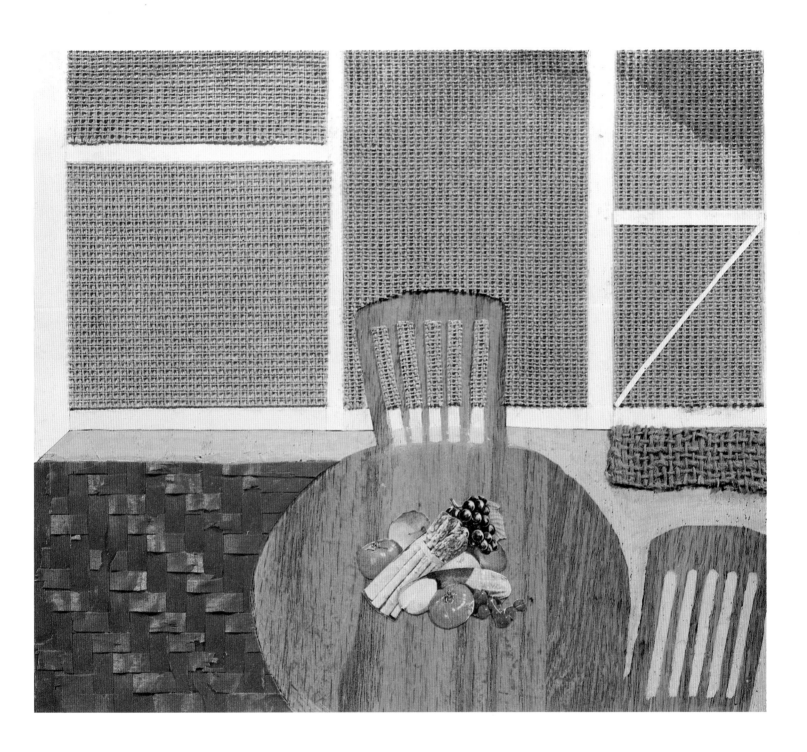

5 ¹⁹⁶⁰
Porch

Mixed media and collage on board,

22.9 x 25.4 cm

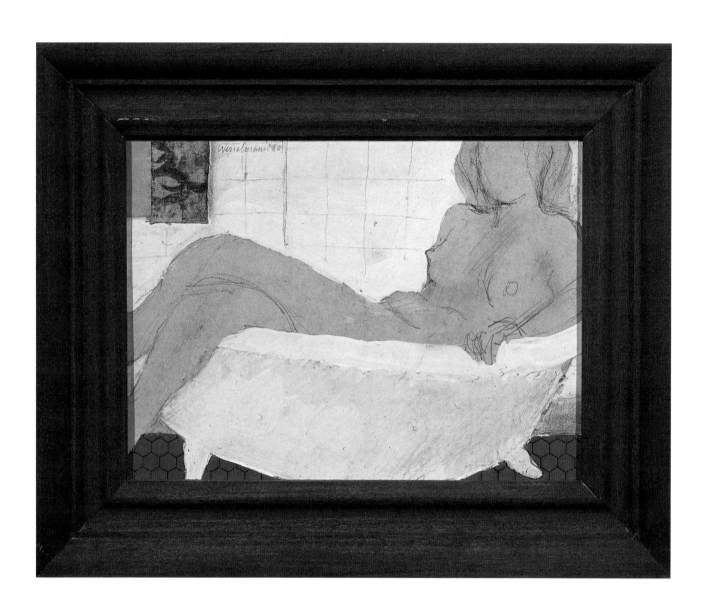

6 1960
Little Bathtub Collage # 1

Mixed media and collage on board,

14 x 19.1 cm

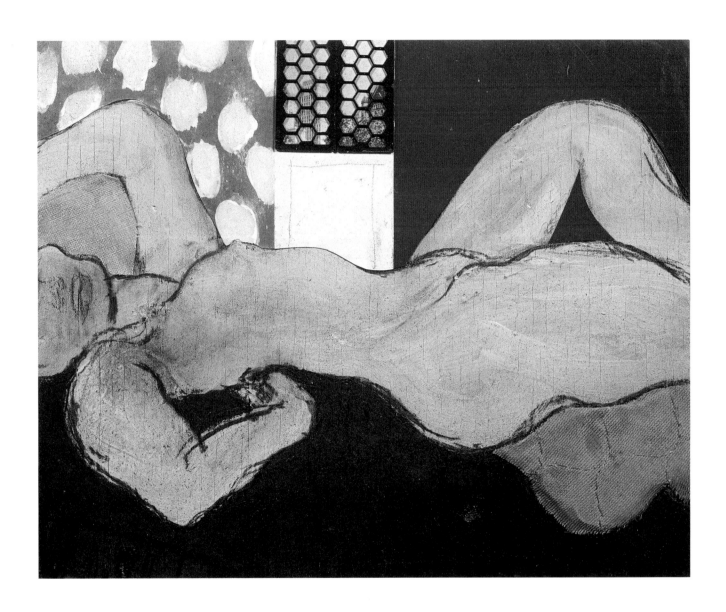

7 1961
Little Great American Nude # 1
Mixed media and collage on board,
16.2 x 20.3 cm

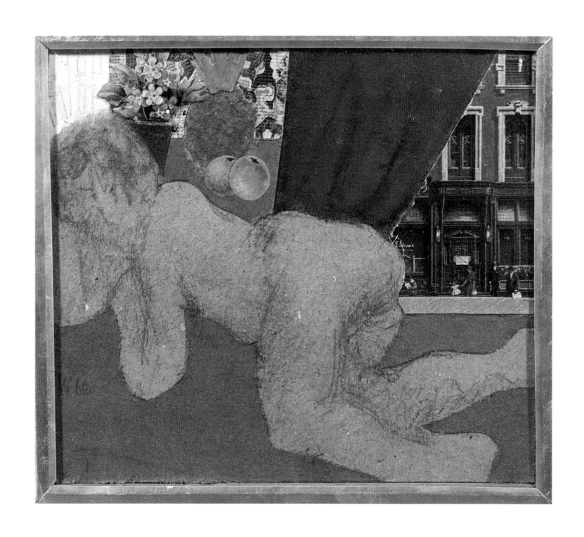

8 1960
14th Street Nude # 1

Mixed media and collage on board,

11.7x13.3 cm

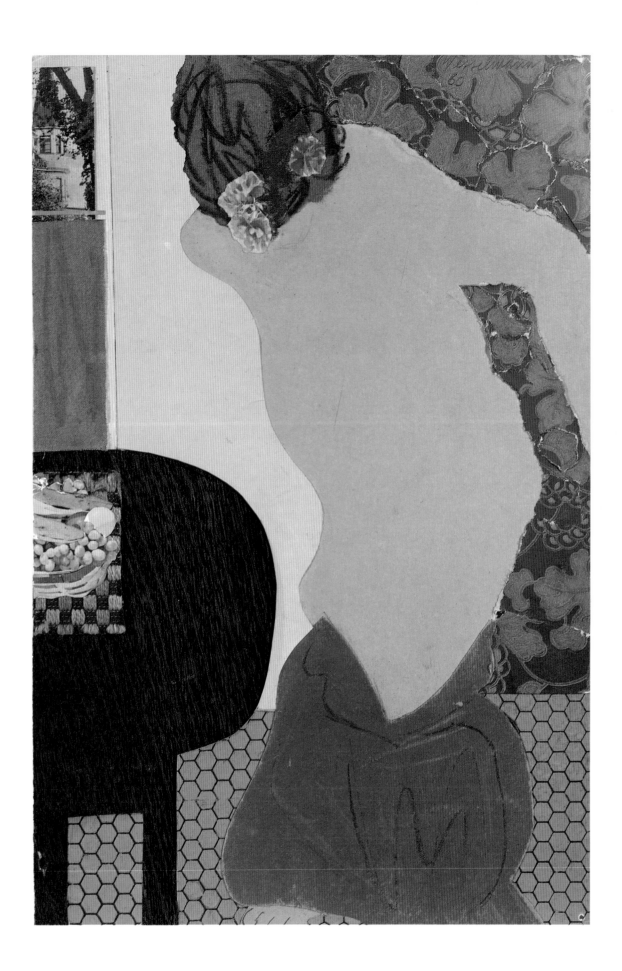

9 1960
Judy Undressing

Mixed media and collage on board,
31.1 x 20.3 cm

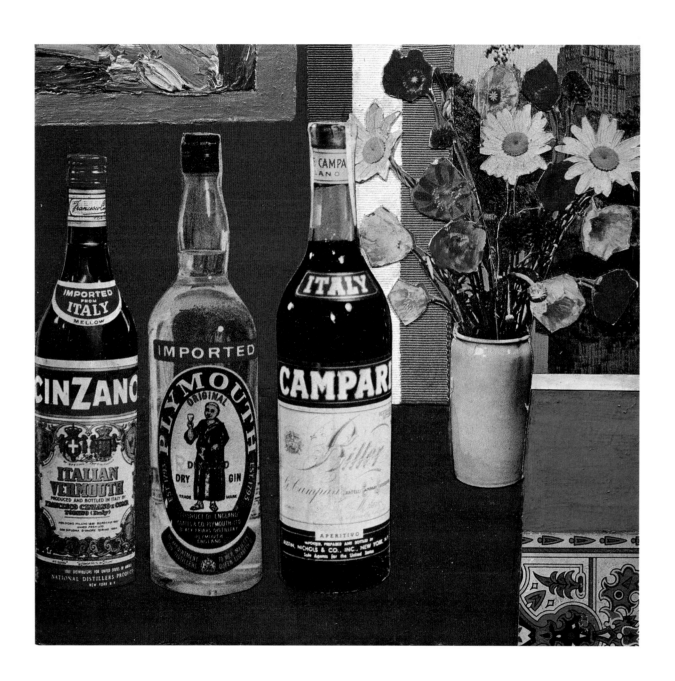

10 ¹⁹⁶² Little Still Life # 1

Liquitex and collage on board,

15.2x16.5 cm

Collage Paintings

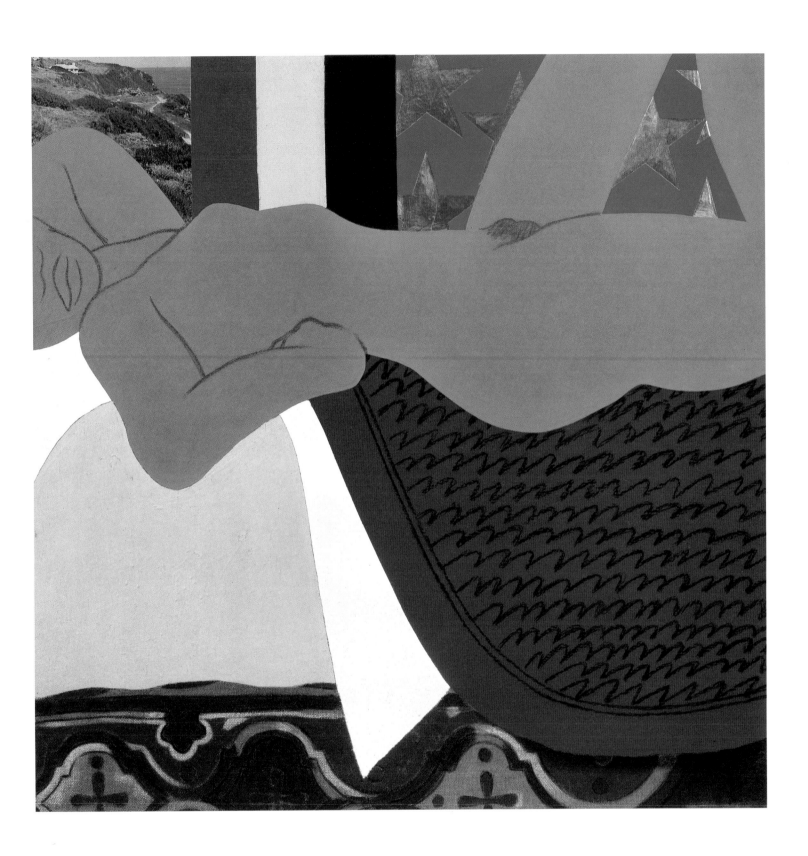

11 ¹⁹⁶¹
Great American Nude # 1
Mixed media and collage on board,
121.9 x 121.9 cm

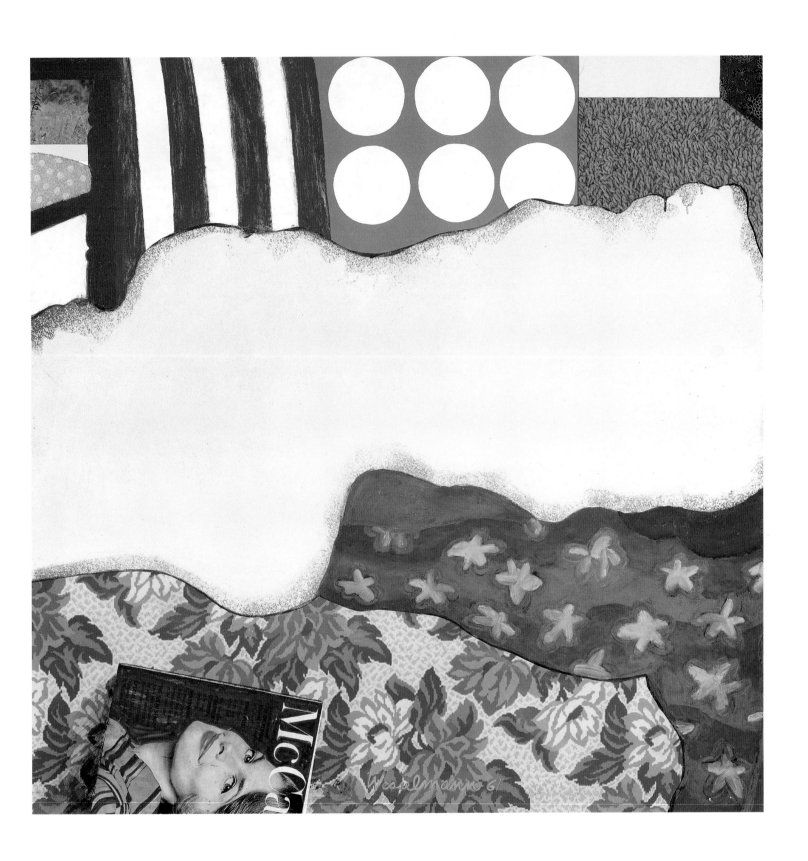

12 ¹⁹⁶¹
Great American Nude # 12
Mixed media and collage on board,
121.9 x 121.9 cm

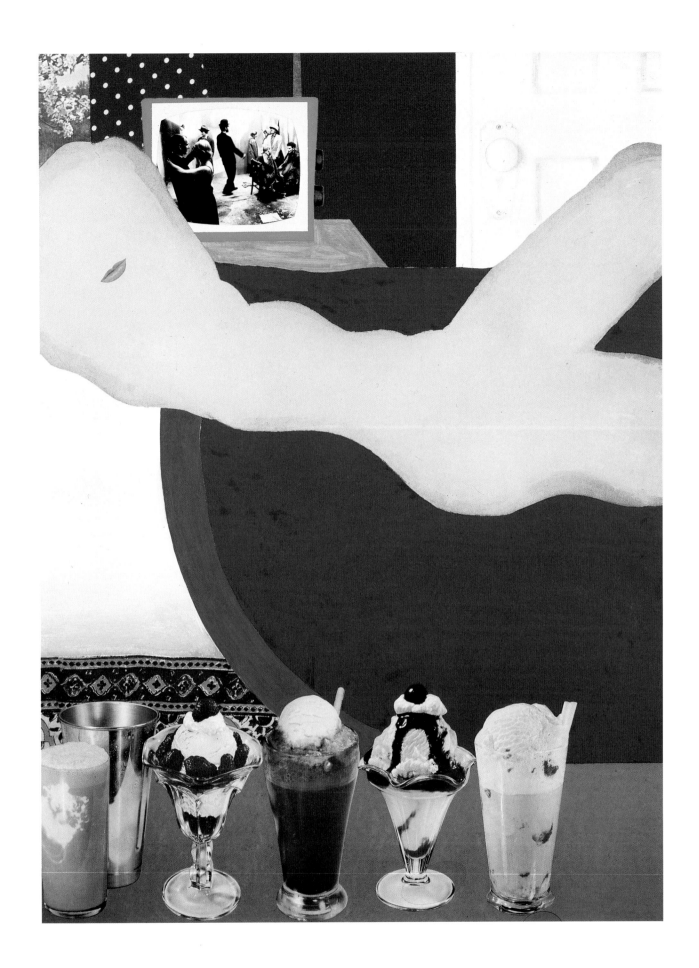

13 ¹⁹⁶²
Great American Nude # 27

Enamel and collage on board,

121.9 x 91.4 cm

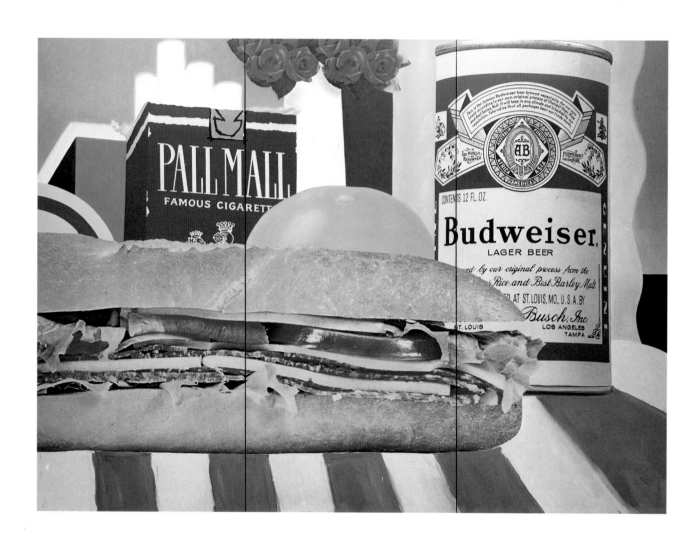

14 ¹⁹⁶³ Still Life # 33

Oil and collage on canvas, 3 sections,

335.3 x 457.2 cm

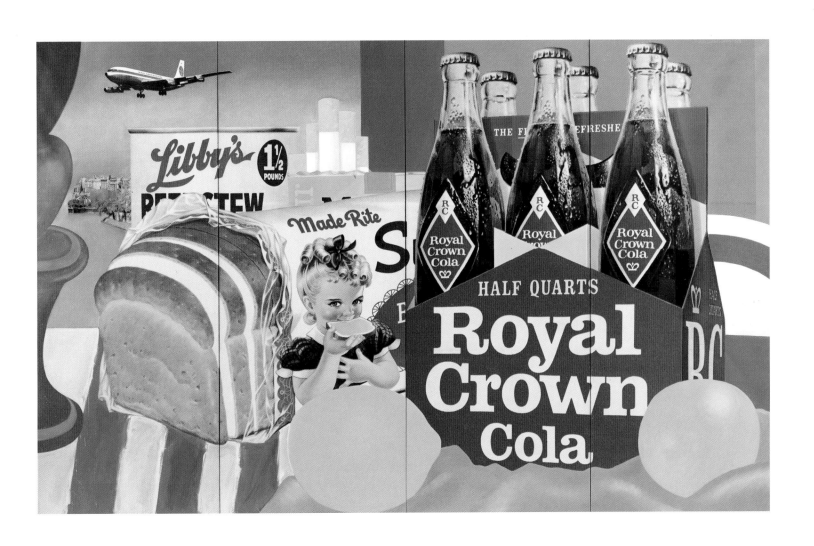

15 ¹⁹⁶³
Still Life # 35

Oil and collage on canvas, 4 sections,

304.8 x 487.7 cm

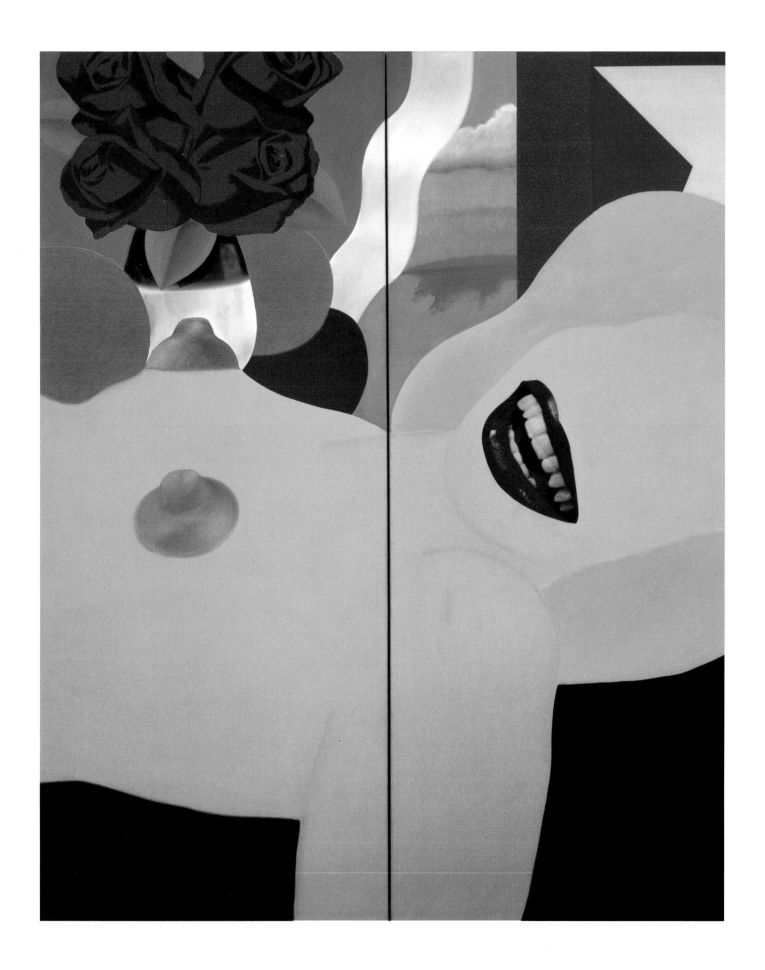

16 ¹⁹⁶⁴ Great American Nude # 53

Oil and collage on board, (2 sections),

each 304.8 x 243.8 cm

Assemblages

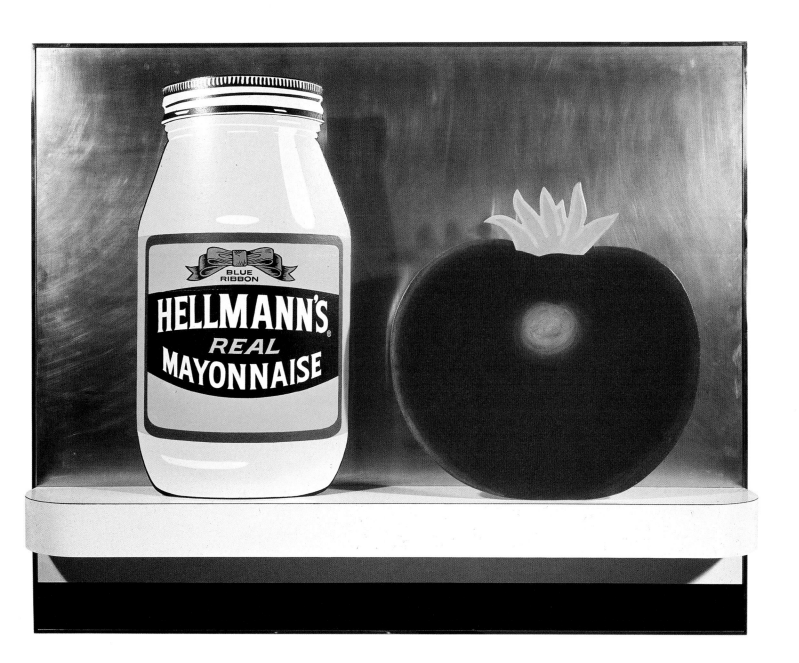

17 ¹⁹⁶⁴ Still Life # 48

Acrylic, collage and assemblage and formica on board,

121.9 x 152.4 x 20.3 cm

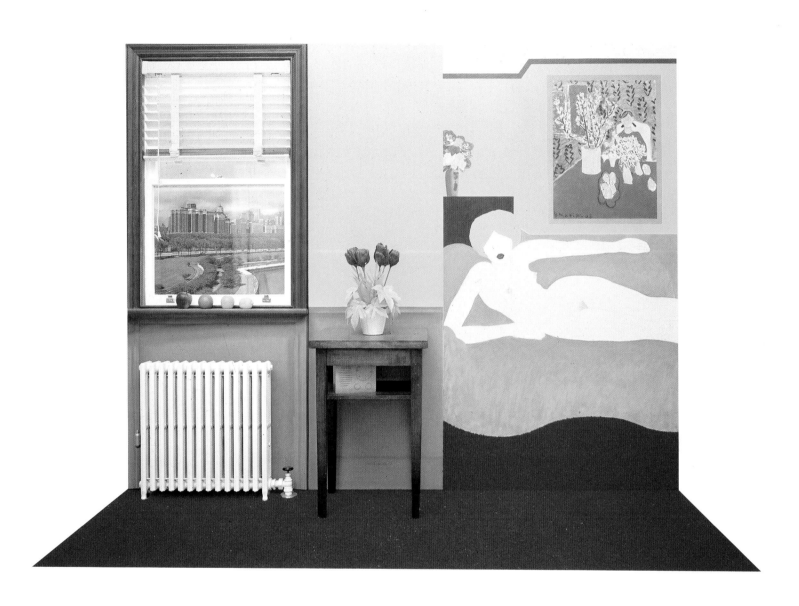

18 1963
Great American Nude # 48

Oil and collage on canvas, acrylic and collage on board,
enameled radiator and assemblage (including window illumination)
213.3 x 274.3 x 86.3 cm

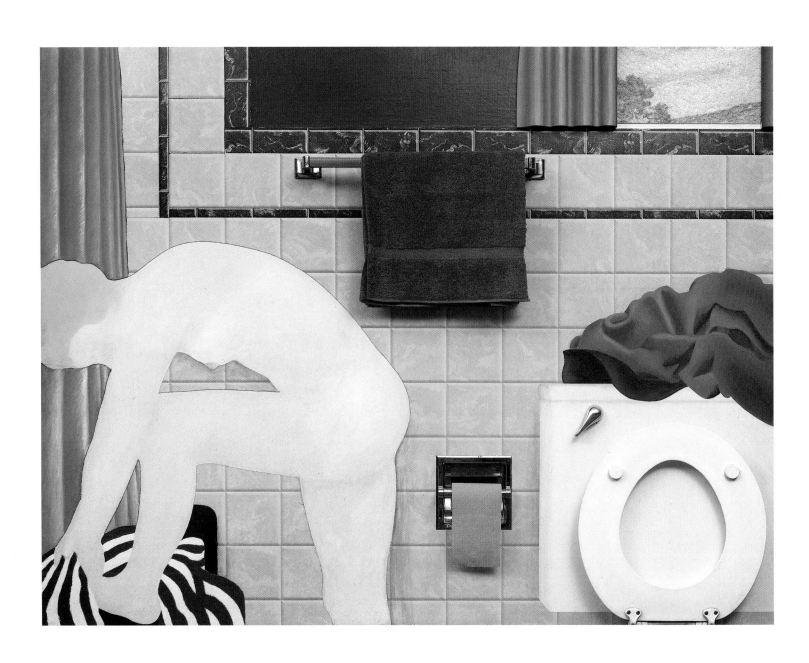

19 ¹⁹⁶³
Bathtub Collage # 1

Mixed media, collage and assemblage on board,

122.5 x 152.5 x 60.8 cm

20 ¹⁹⁶⁴
Little Still Life # 18

Acrylic, collage and assemblage on board
(with working radio),
14.6 x 16.5 x 6.7 cm

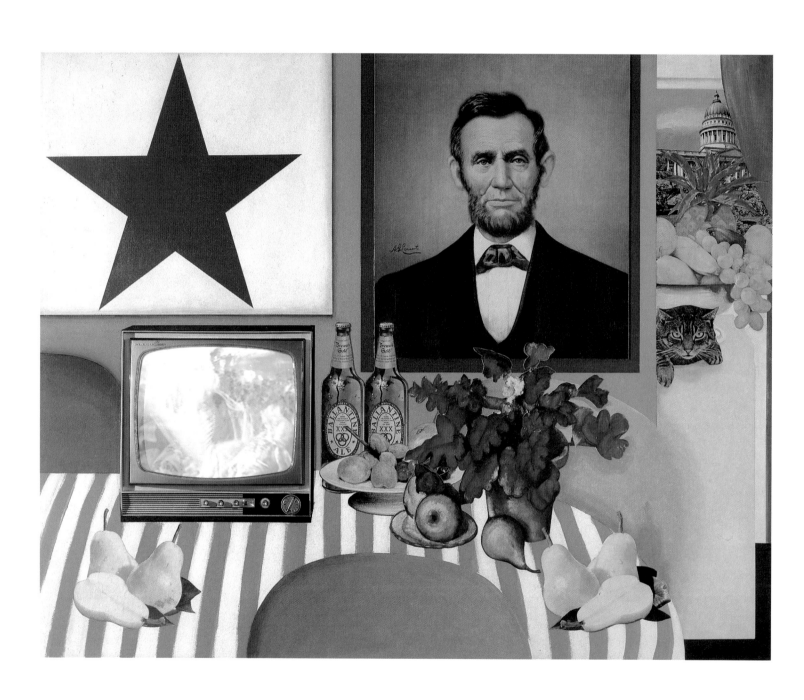

21 ¹⁹⁶³ Still Life # 28

Acrylic, collage and working TV on board,

121.9 x 152.4 cm

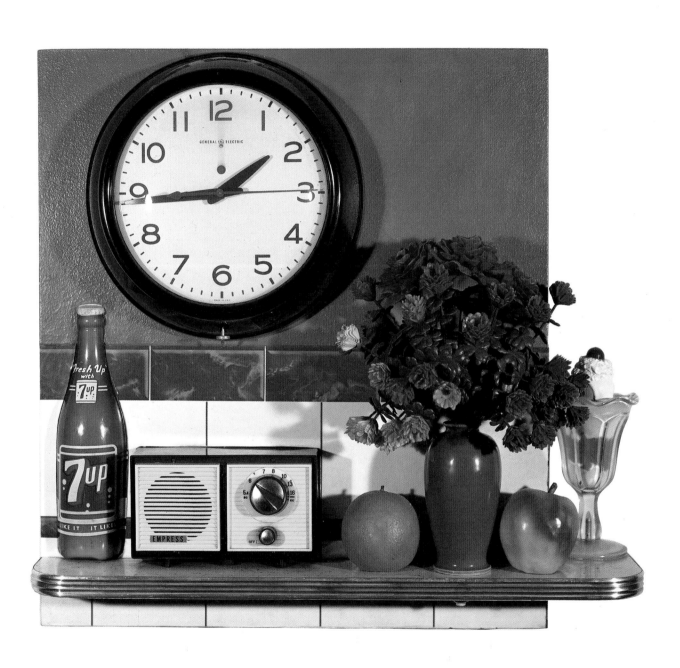

22 1964
Still Life # 38
Oil, acrylic, collage and assemblage,
(incl. working clock and radio),
55.9 x 59.7 x 20.3 cm

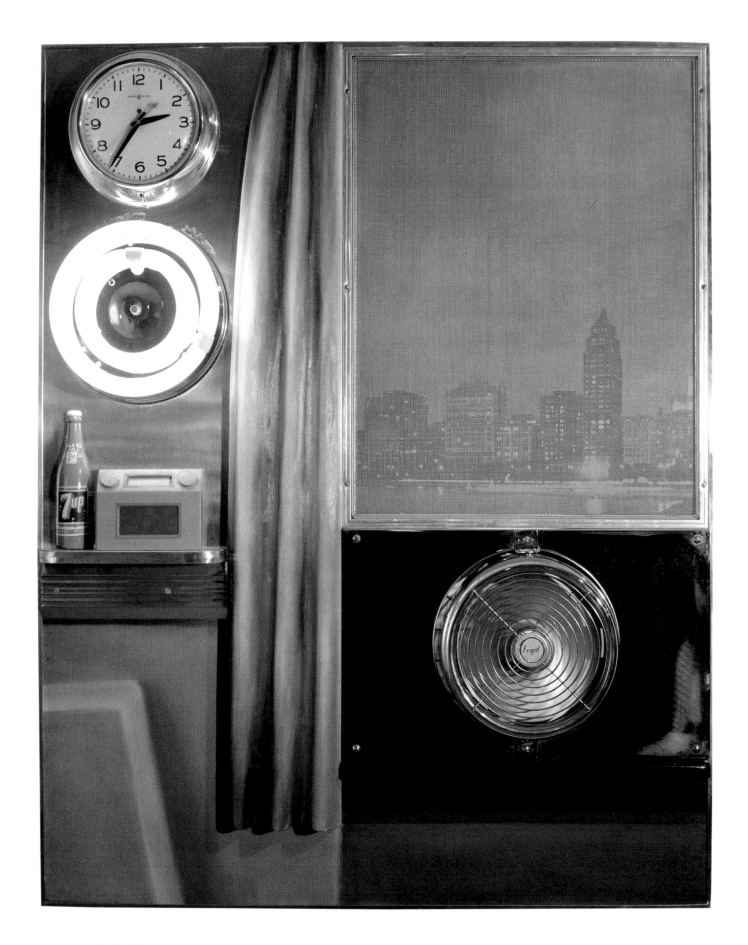

23 ¹⁹⁶⁴
Interior # 2
Acrylic, collage, assemblage,
(incl. working fan, clock, and fluorescent light),
152.4x121.9x12.7 cm

Plastics

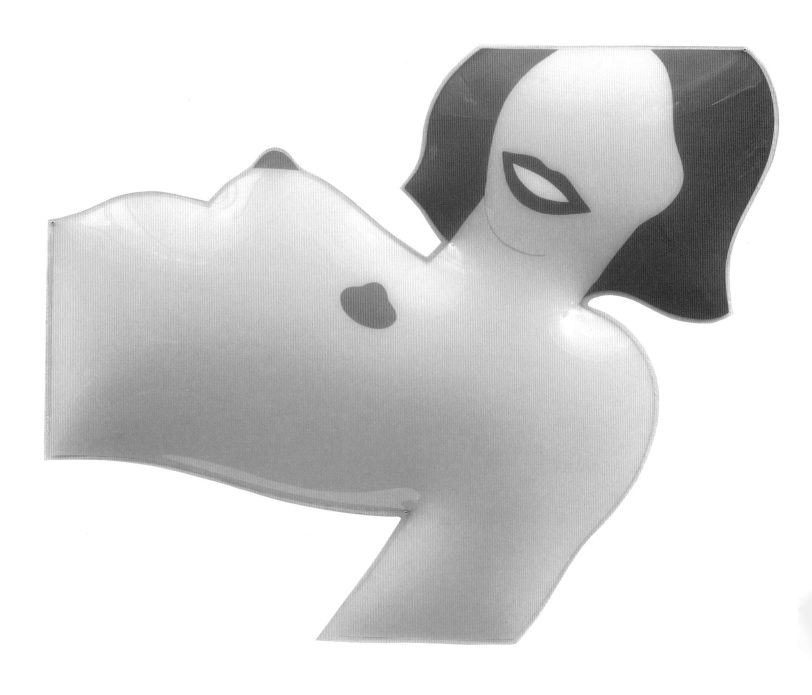

24 ¹⁹⁶⁵
Great American Nude # 74

Painted molded plastic,
88.9 x 110.5 x 7.62 cm

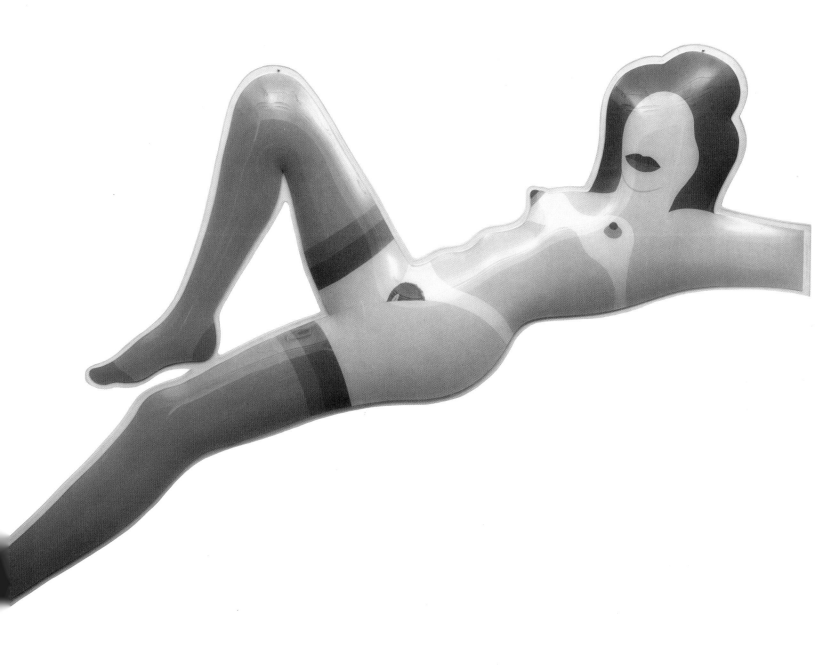

25 1966
 Great American Nude # 82
 Painted molded plexiglas
 (Edition of five each unique)
 137.2 x 200.7 x 7.6 cm

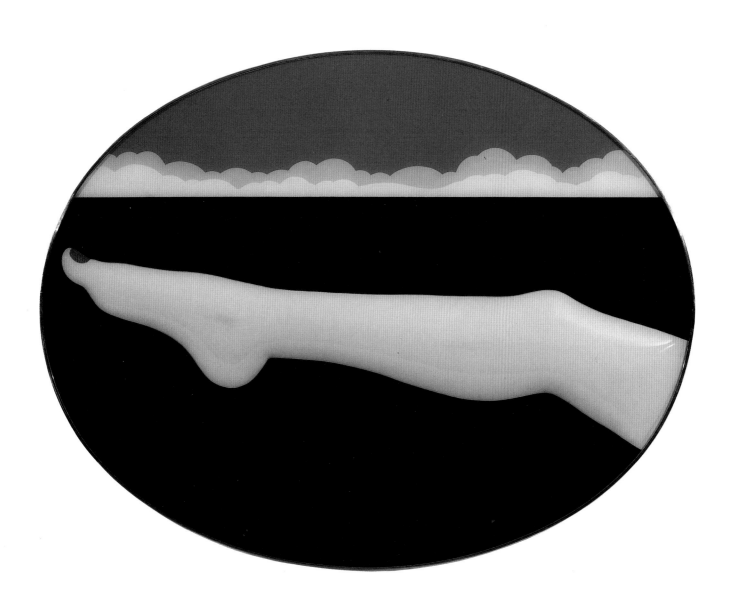

26 ¹⁹⁶⁶
Seascape # 10

Painted molded plastic,
113 x 148.6 x 4.4 cm

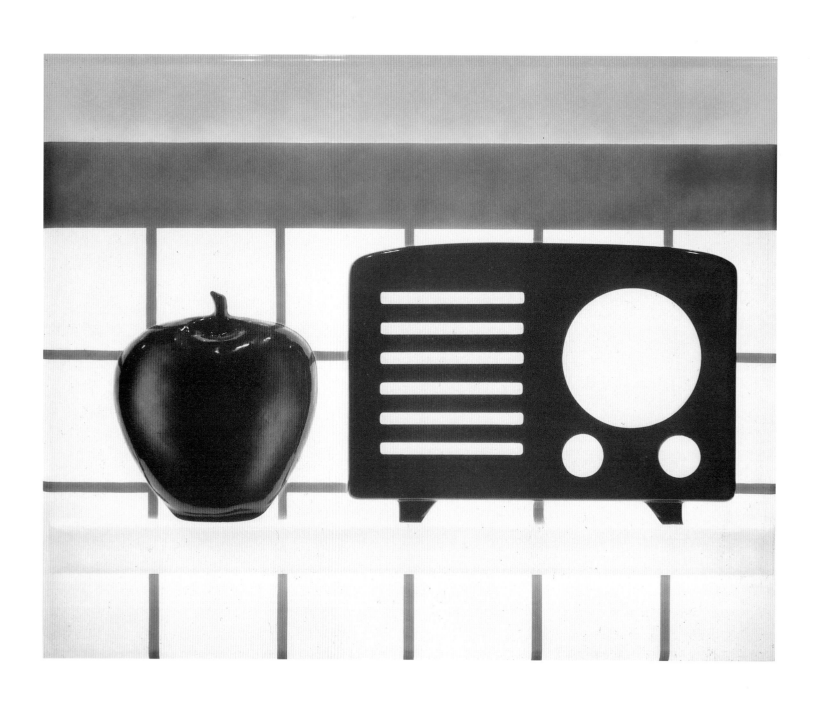

27 ¹⁹⁶⁴ Still Life # 46
Illuminated painted molded plastic,
118.1 x 147.3 x 12.7 cm

Shaped and Standing Paintings

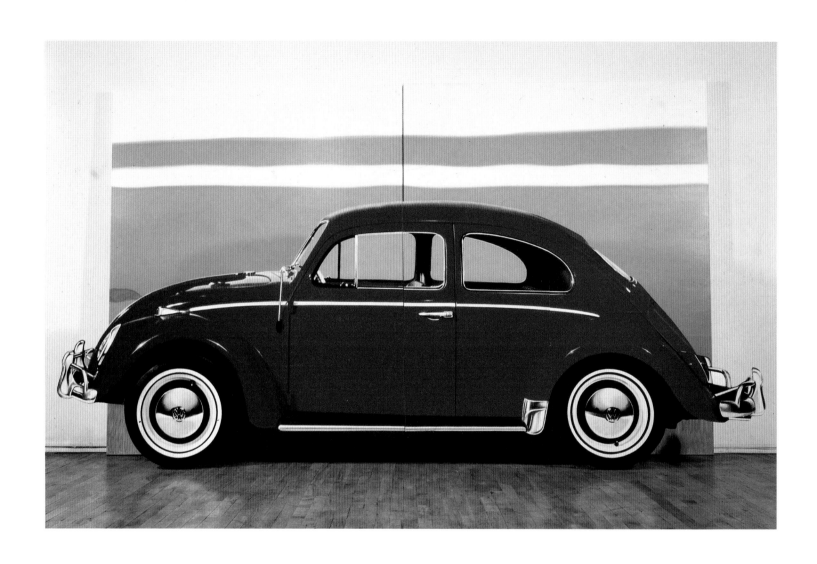

28 ¹⁹⁶⁵ Landscape # 5
Collage, acrylic and oil on canvas,
(2 separate sections, one freestanding),
213.4 x 367 x 45.7 cm

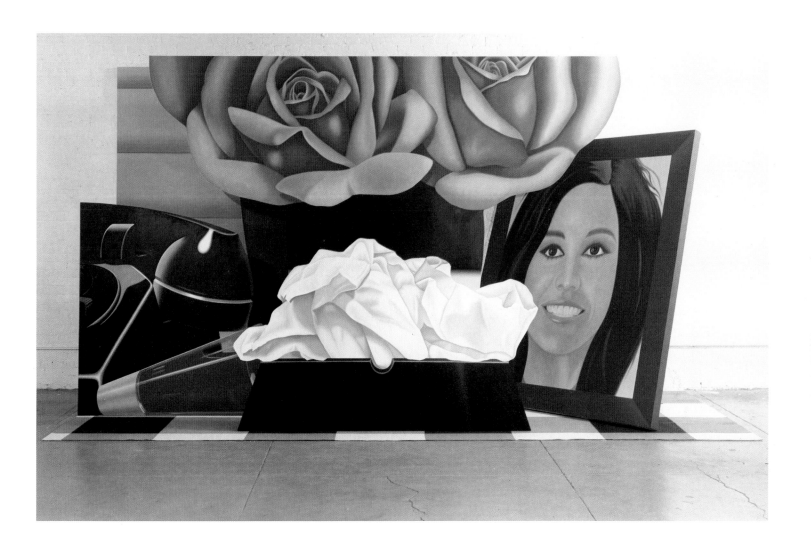

29 ¹⁹⁷²
Still Life # 59
Oil on canvas,
(5 separate sections, plus carpet), four freestanding,
268 x 484.5 x 210.8 cm

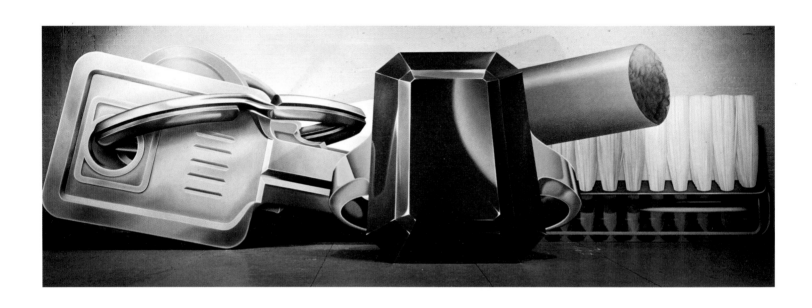

30 1976
Still Life # 61

Oil on canvas, 4 freestanding sections,

265.4 x 993.1 x 200.7 cm

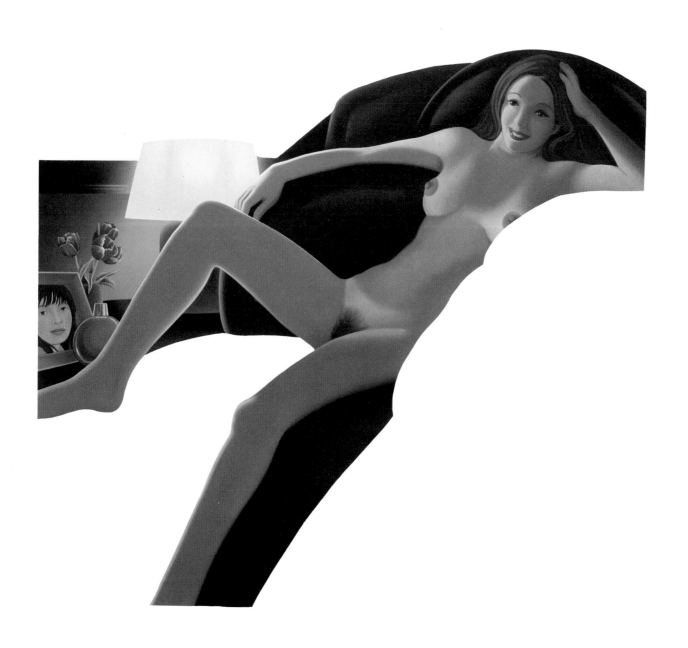

31 1977–1980
 Nuded with Lamp

 Oil on canvas,

 189.6 x 222.3 cm

 (78½ x 87¼ inches)

32 1982
Black Bra and Green Shoes

Oil on canvas,

172.7 x 240 cm

Drop Outs

33 ¹⁹⁶⁷ Seascape # 19
Liquitex on shaped canvas,
182.9 x 152.4 cm

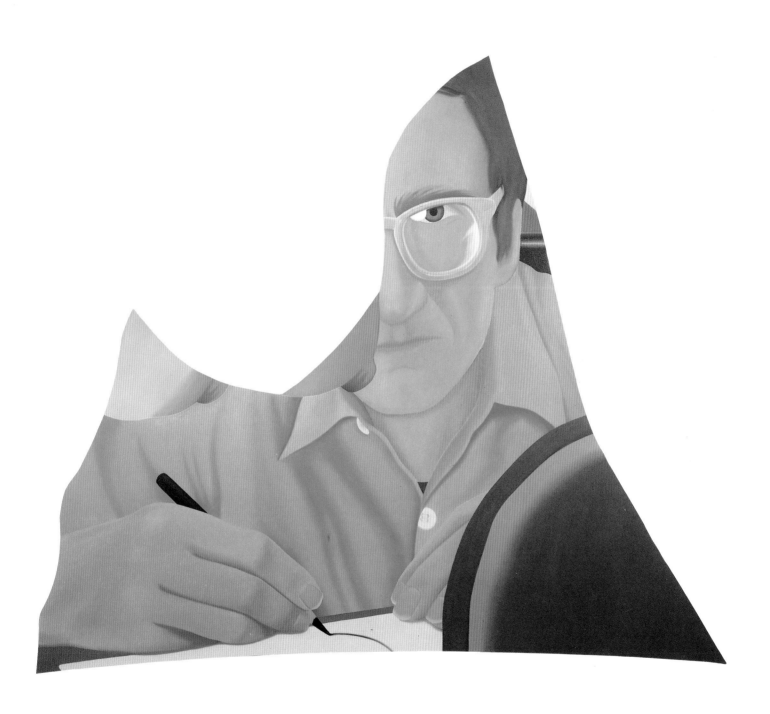

34 ¹⁹⁸³
Self-Portrait while Drawing
Oil on shaped canvas,
188 x 221 cm

Bedroom Paintings

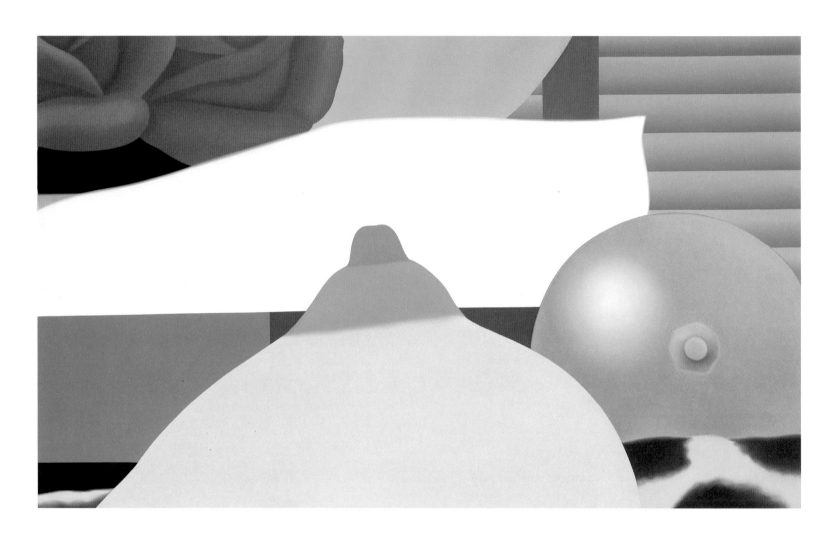

35 1967–68
Bedroom Painting # 6
Oil on canvas,
132.1 x 213.4 cm

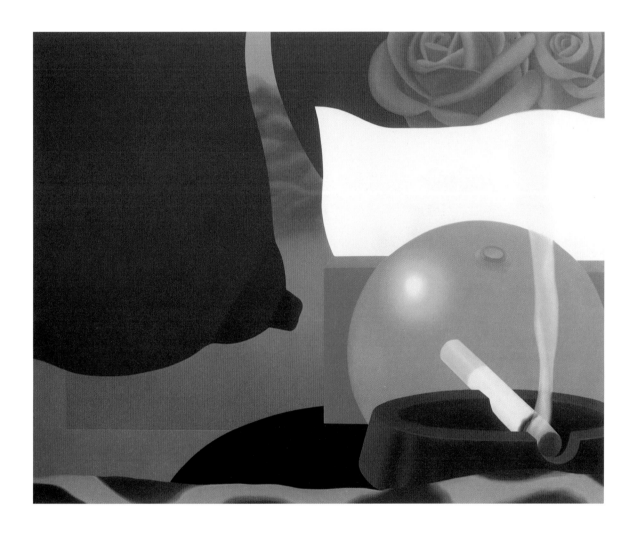

36 1969
Bedroom Painting # 13
Oil on canvas,
147.3 x 182.9 cm

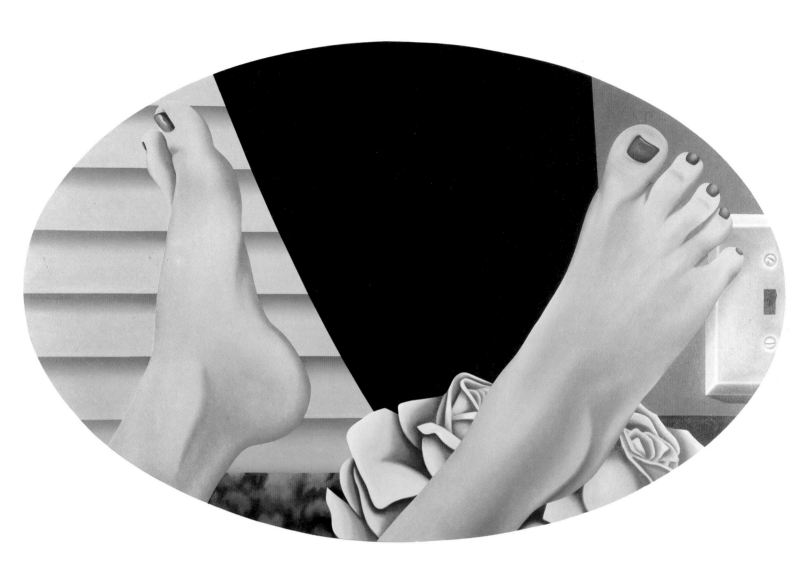

37 1969–75
Bedroom Painting # 21
Oil on canvas,
151.8 x 238 cm

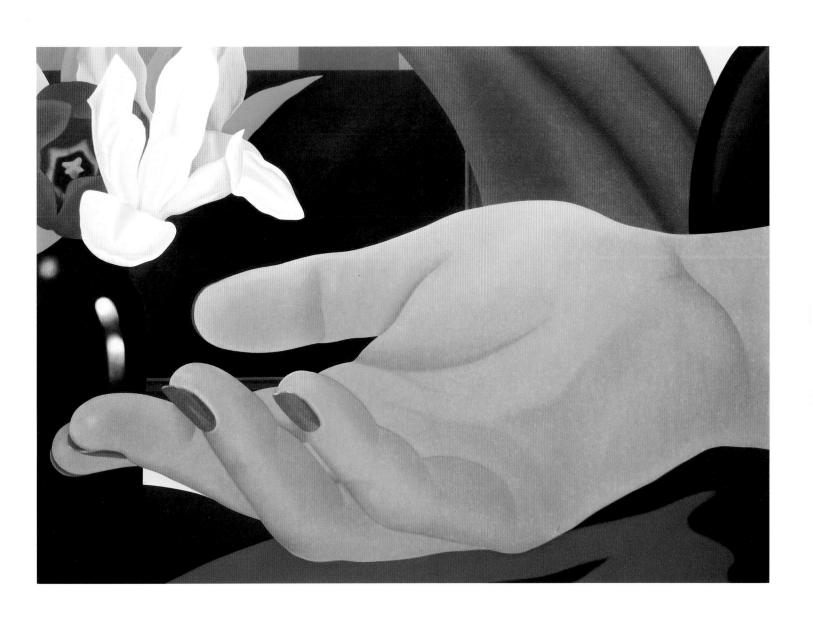

38 1972–82
Gina's Hand
Oil on canvas,
149.9 x 208.3 cm

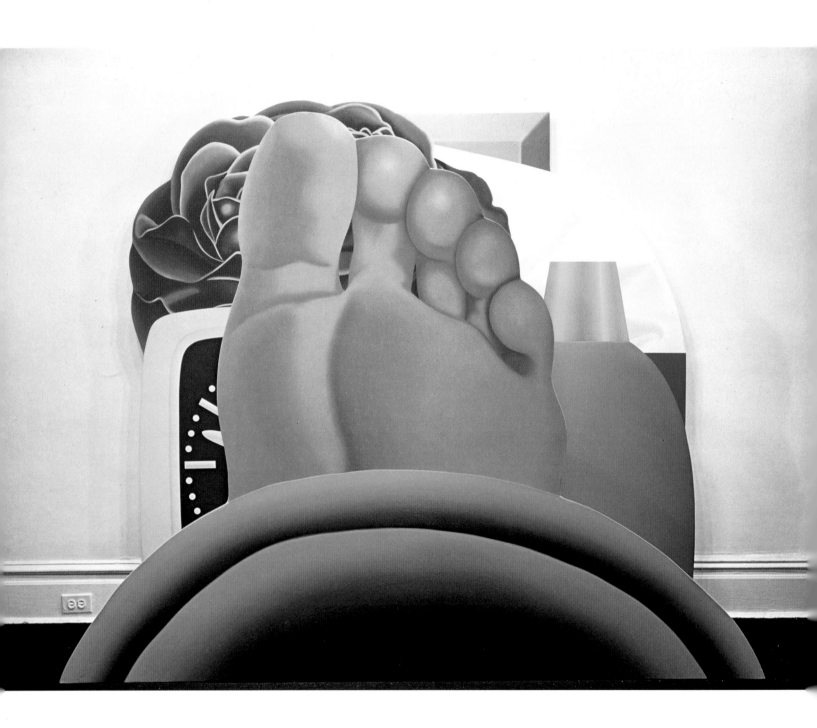

39 1970
Bedroom Painting # 24
Oil on canvas, (2 sections),
190.5 x 236.9 x 63.5 cm

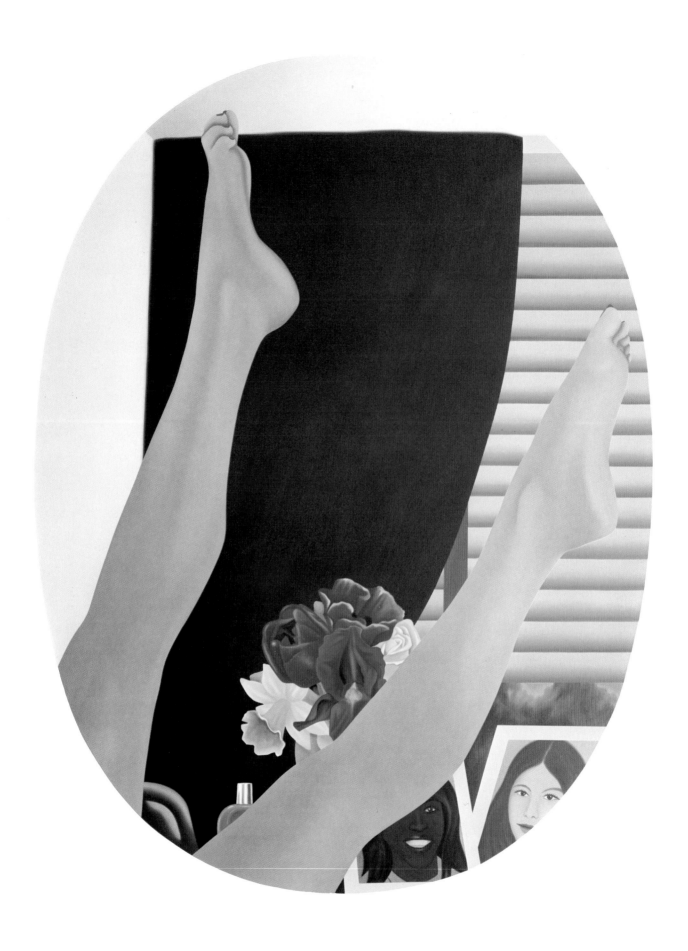

40 1975
Bedroom Painting # 35
Oil on canvas,
213.4 x 167.6 cm

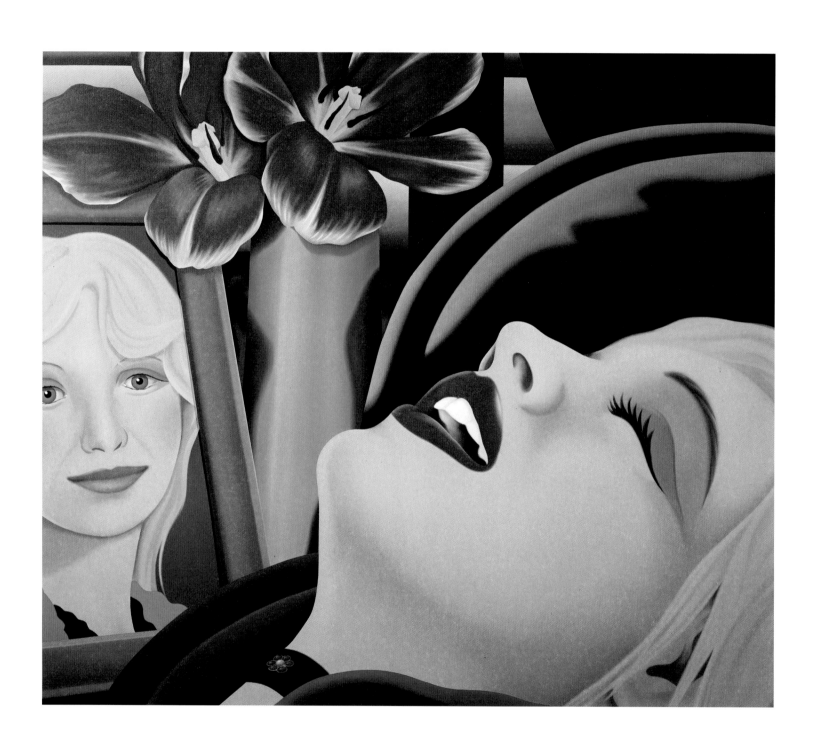

41 1978
Bedroom Painting # 38
Oil on canvas,
213.4 x 246.4 cm

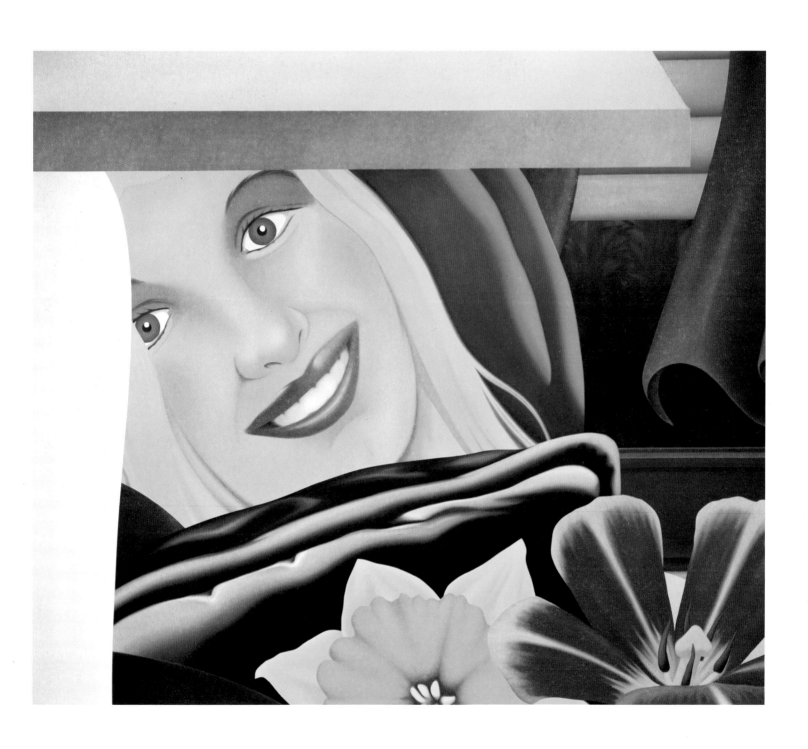

42 1978
Bedroom Painting # 41
Oil on canvas,
243.8 x 284.5 cm

43 ¹⁹⁸³
Bedroom Painting # 60
Oil on masonite and steel,
205.1 x 298.5 cm

44 1983
Bedroom Painting # 65
Oil on canvas,
179.1 x 349.2 cm

45 1983
Bedroom Painting # 71
Oil on canvas, (2 sections),
229.9 x 257.2 cm

Smokers

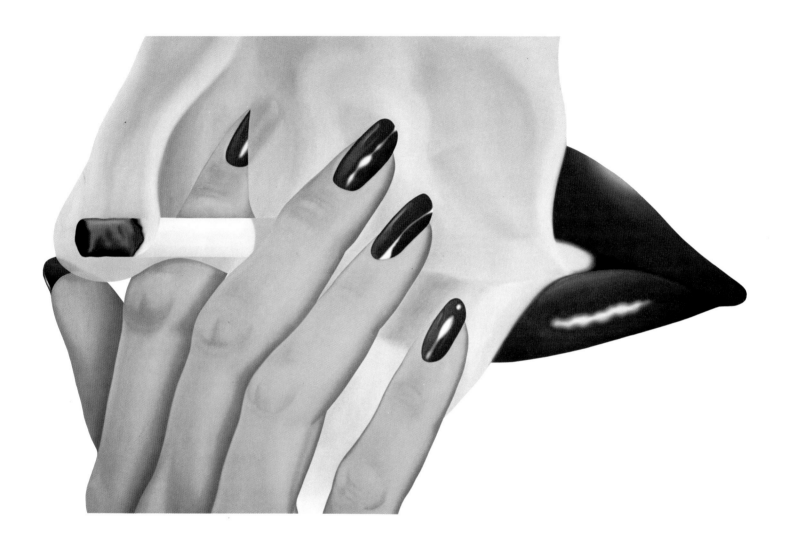

46 ¹⁹⁷³
Smoker # 8

Oil on shaped canvas,
275 x 415.9 cm

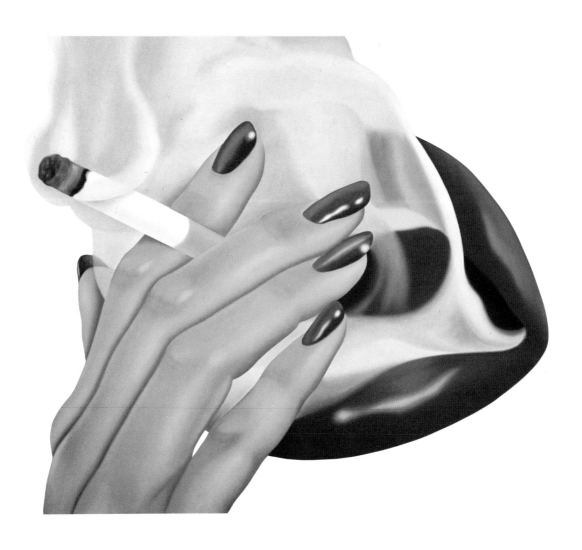

47 ¹⁹⁷³
Smoker # 9
Oil on shaped canvas,
210.8 x 227.3 cm

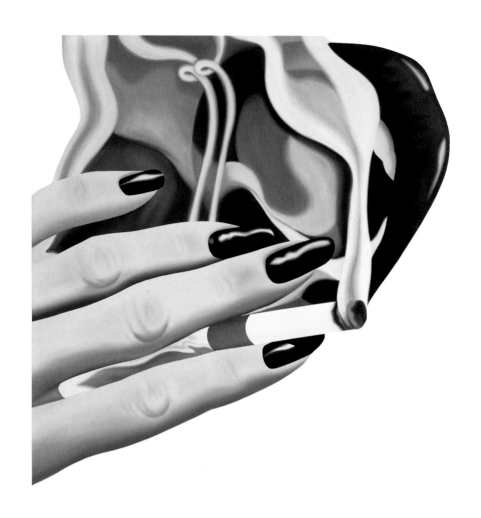

48 1975
Smoker # 20
Oil on canvas,
181.6 x 170.2 cm

Metal Works

49 1984
Amy Reclining (Artist's variation)
Enamel on cut-out aluminium,
71.1x167.6 cm

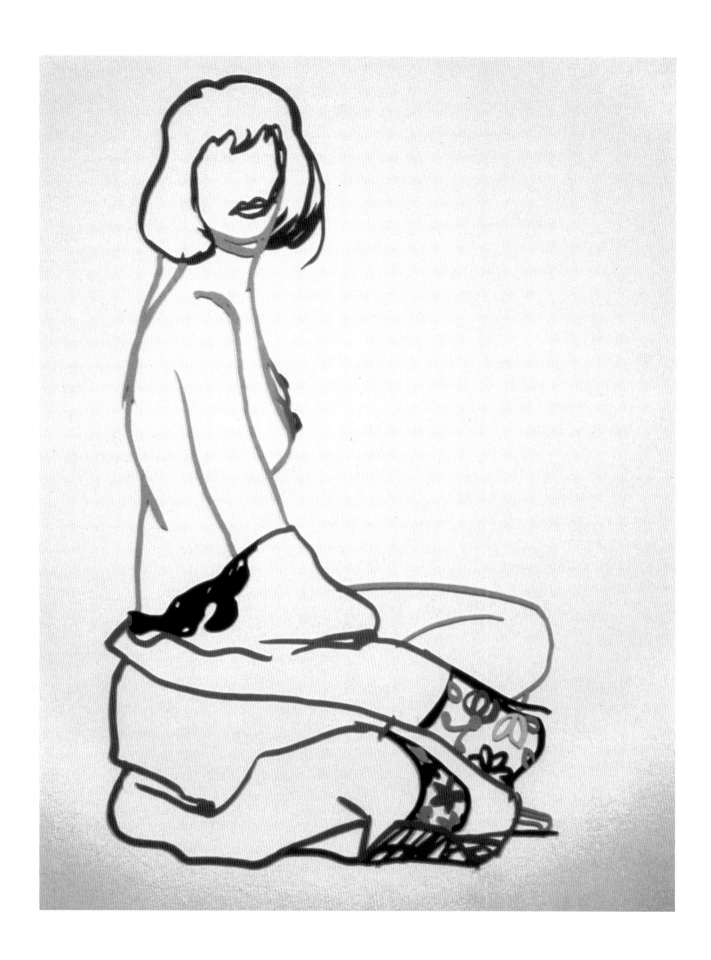

50 1986–89
Monica Sitting with Robe Half Off
Enamel on laser-cut steel,
99.1 x 58.4 cm

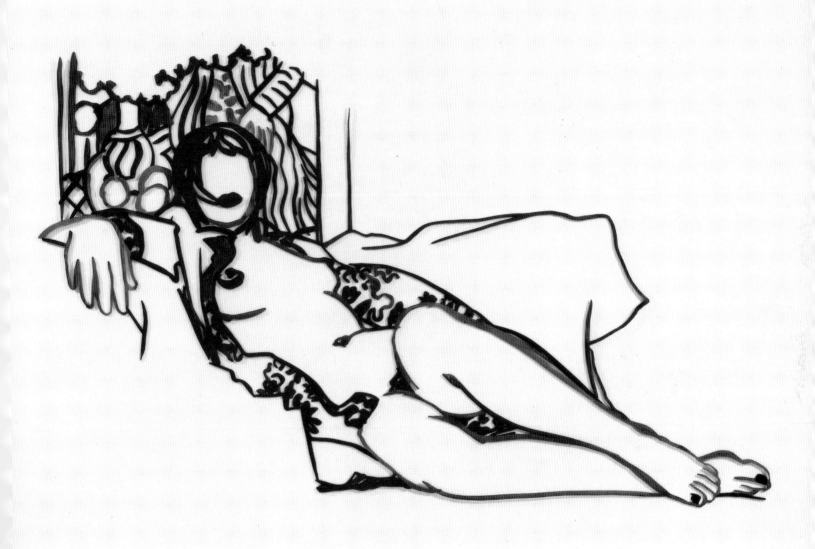

51 1988
Monica Nude with Matisse (Black Variation)

Enamel on cut-out steel,

129.5 x 218.4 cm

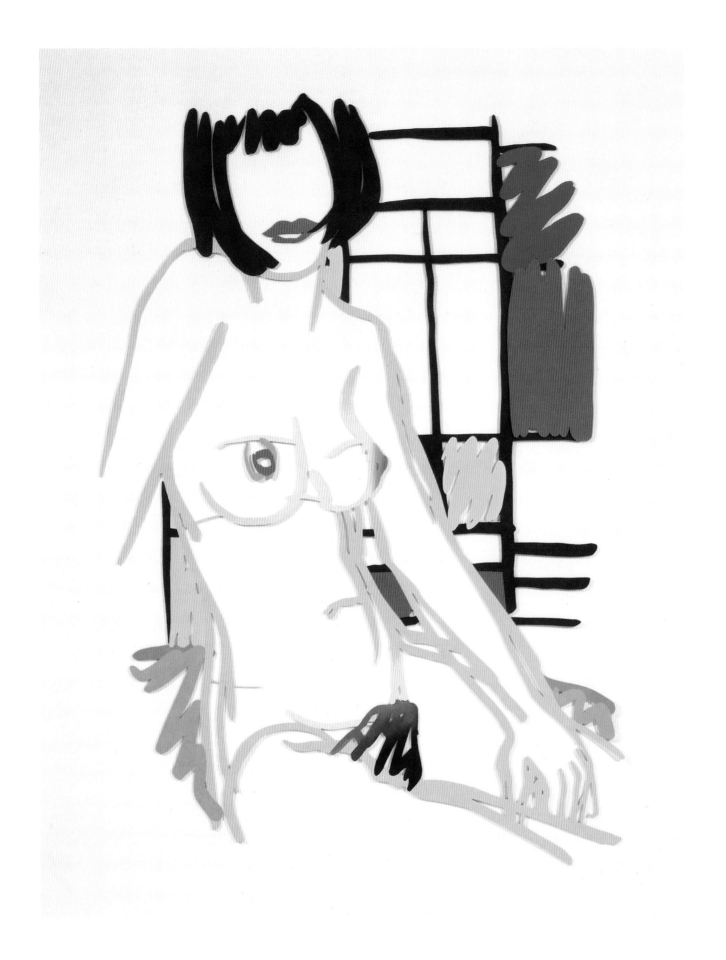

52 1988
Monica Sitting with Mondrian
Enamel on cut-out steel,
154.9 x 106.7 cm

53 1985
 Bedroom Blonde Doodle with Photo
 Enamel on cut-out aluminium,
 193 x 226 cm

54 1978–90
Sketchbook Page with Hat and Goldfish

Enamel on cut-out steel,

170.2 x 182.9 cm

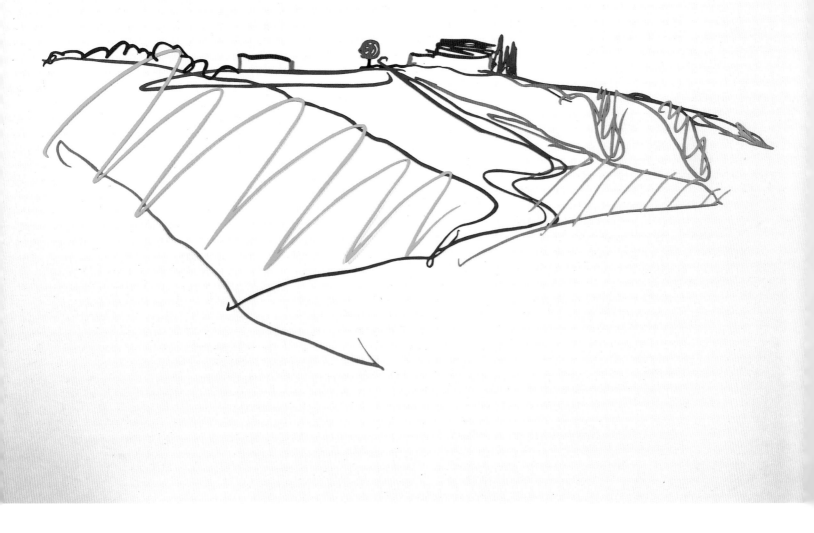

55 1987
 Quick Sketch from the Train (Italy)
 Enamel on cut-out steel,
 114.3 x 254 cm

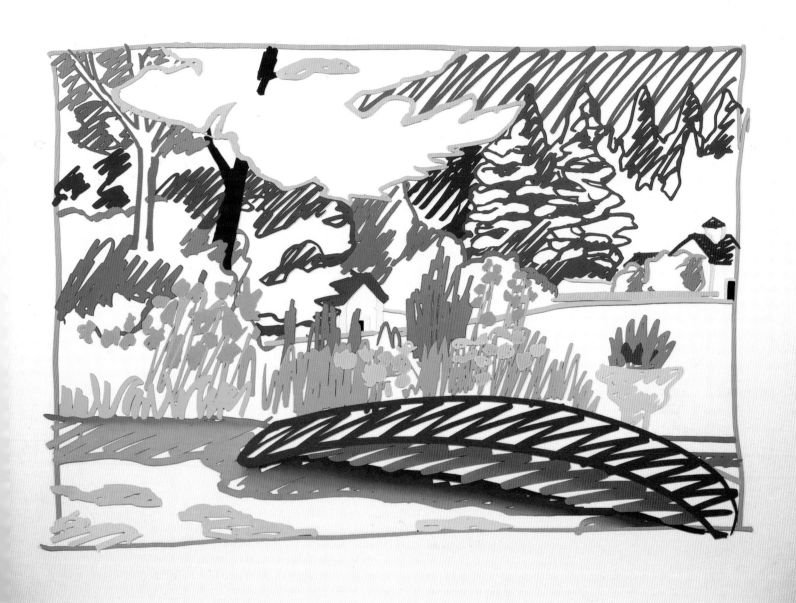

56 1985–89
The Red Canoe

Enamel on laser-cut steel,
162.6 x 233.7 cm

57 1988
Fast Sketch Still Life with Abstract Painting (Black)
Enamel on cut-out steel,
152.4 x 238.8 cm

58 1983
Steel Drawing # 1
Enamel on cut-out steel,
182.9 x 233.7 cm

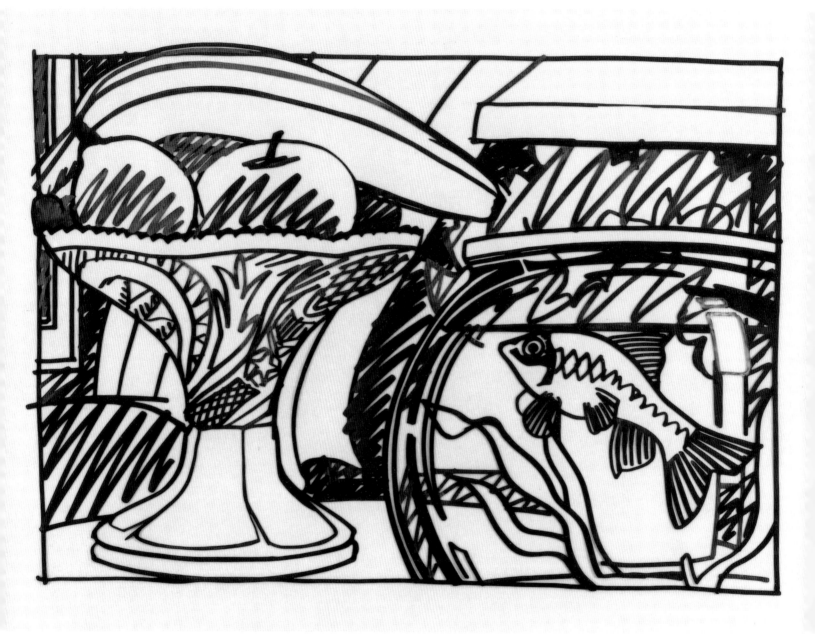

59 1987
 Still Life with Fruit, Flowers and Goldfish (Black variation # 1)
 Enamel on cut-out steel,
 129.5×190.5 cm

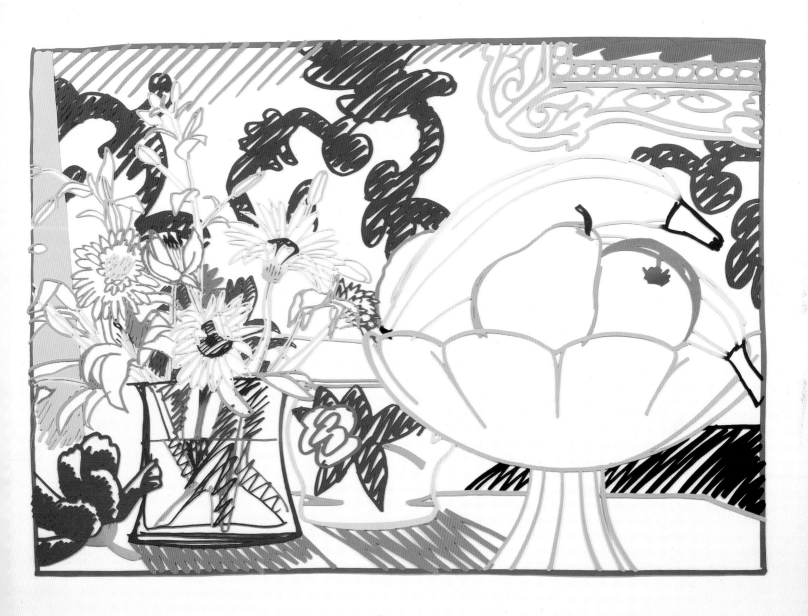

60 1989
Still Life with Wildflowers, Fruit and Cream Pitcher
Enamel on laser-cut steel,
165.1 x 236.2 cm

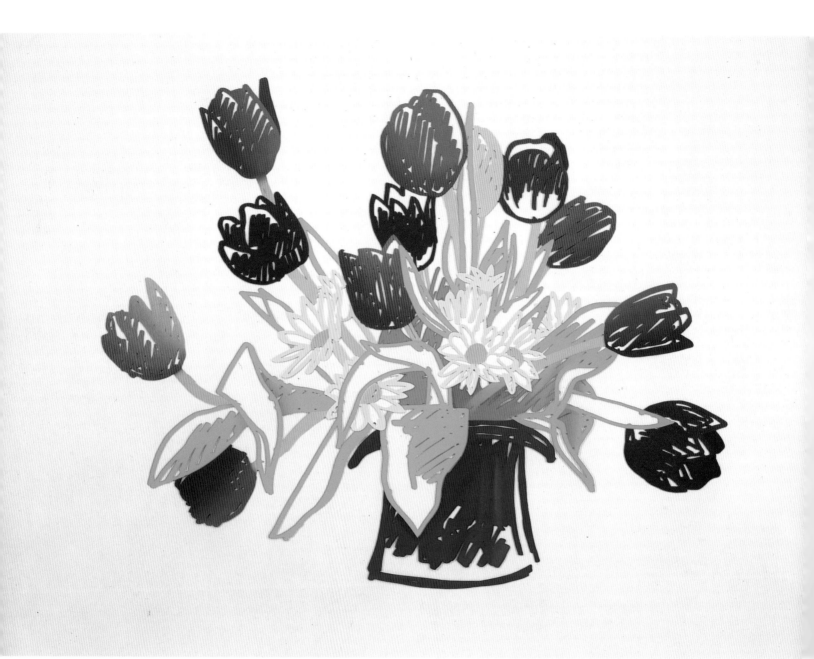

61 1988/91
Birthday Bouquet (Hat Vase)

Alkyd oil on cut-out steel,

171.5 x 219.7 cm

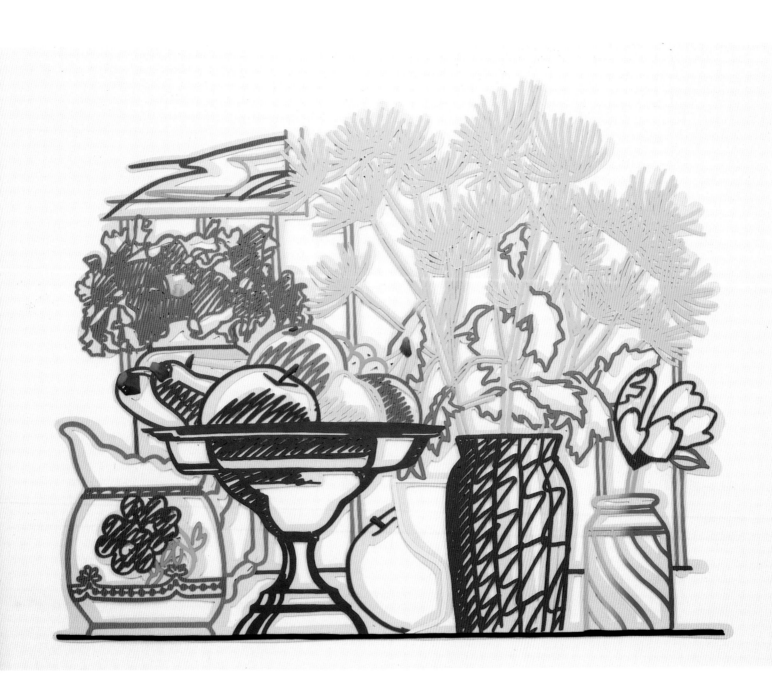

 1985/92
Still Life with Fuji Chrisanthemums (double Layer)

Alkyd oil on cut-out steel,

152.4 x 190.5 cm

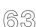 **63** 1988
Fast Sketch Still Life with Fruit and Goldfish

Enamel on cut-out steel,

170.2 x 246.4 cm

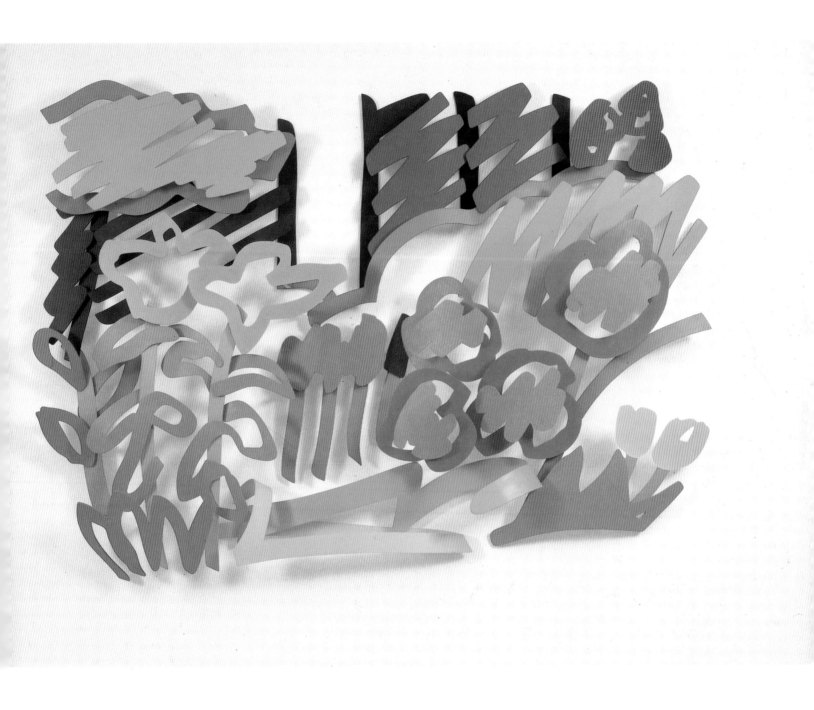

64 1992
In Alice's Front Yard (3-D)
Oil on cut-out aluminium,
160 x 221 x 27.9 cm

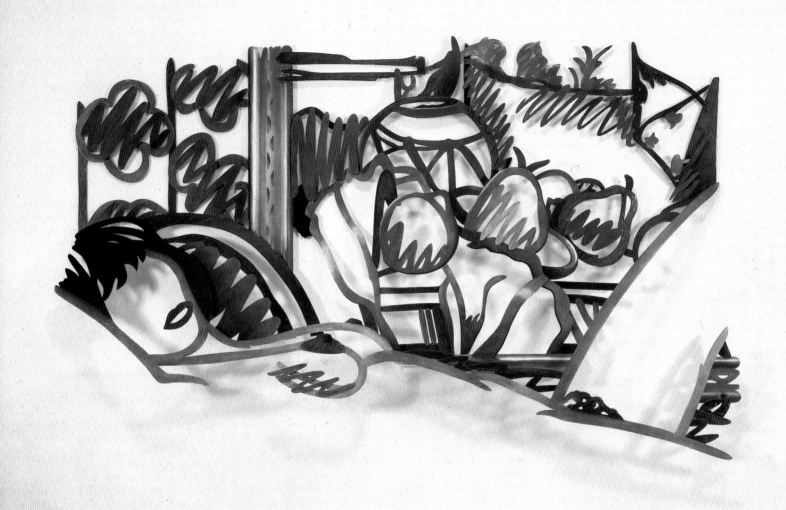

65 1992
Monica Nude with Cézanne (3-D)
Charcoal on cut-out aluminium,
137.2 x 231.1 x 21.6 cm

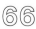 1991
Monica Sitting Cross-Legged (Reverse)
Charcoal on cut-out aluminium,
144.8 x 135.9 cm

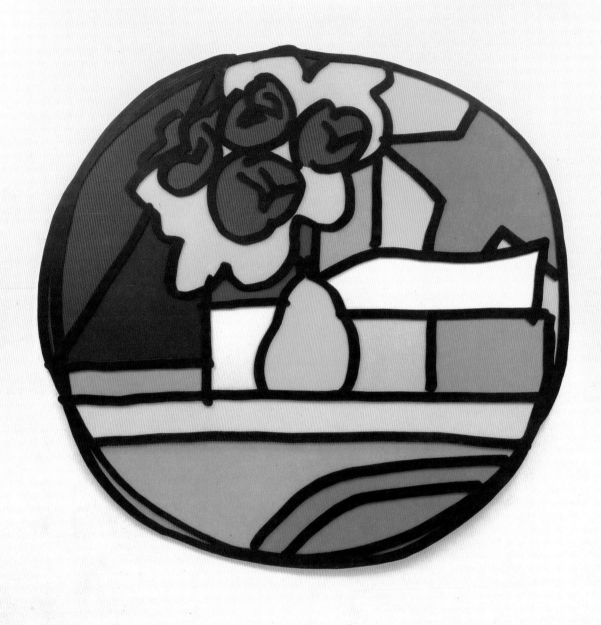

67 1993
Night Time Still Life with Four Roses and Pear

Alkyd oil on aluminium,

158.8 x 167.6 cm

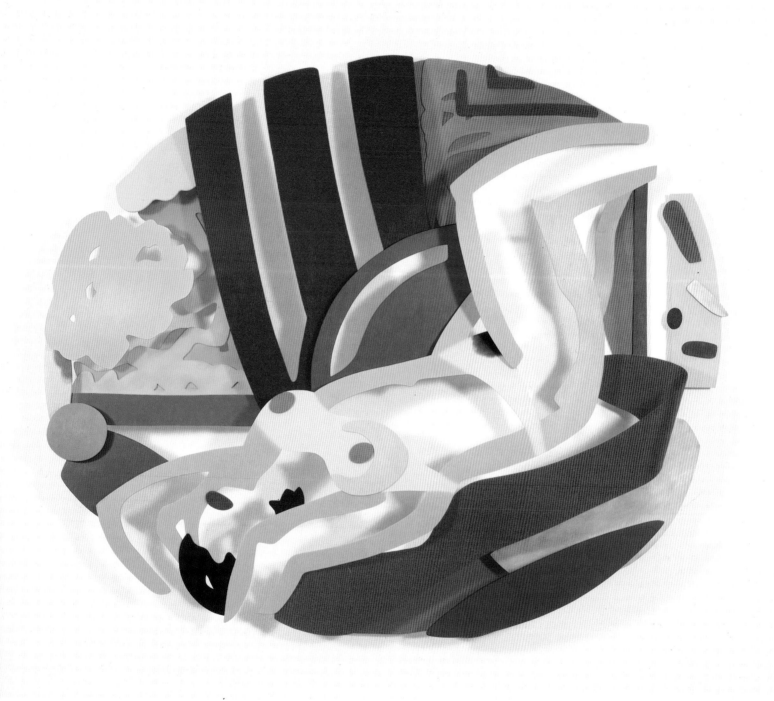

68 1993
Nude Lying Back (3-D)
Oil on cut-out aluminium,
154.9 x 193 x 20.3 cm

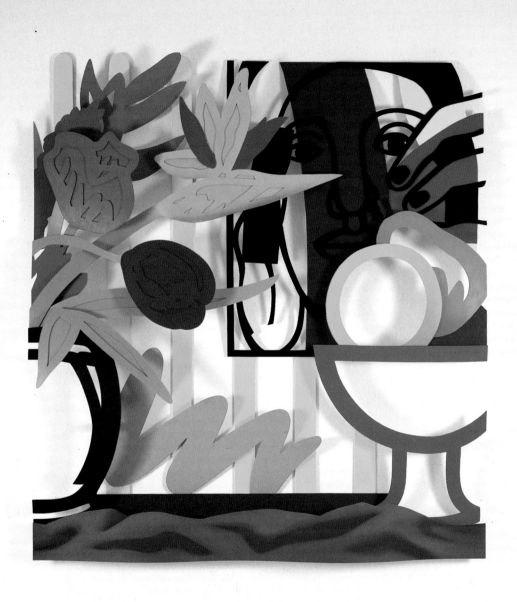

69 1992
Mixed Bouquet and Léger (3-D)
Oil on cut-out aluminium,
190.5 x 177.8 x 22.9 cm

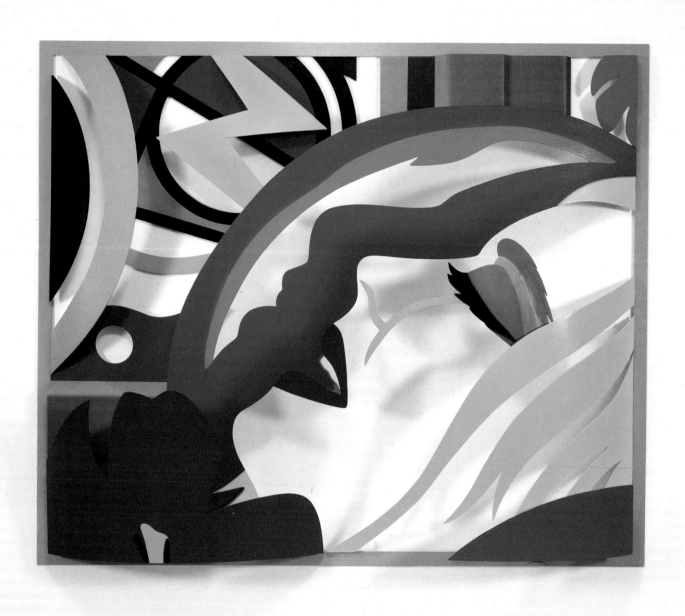

70 1988–92

Bedroom Face with Lichtenstein (3-D) (Artist's variation)

Oil on cut-out aluminium,

173.4 x 208.3 x 33 cm

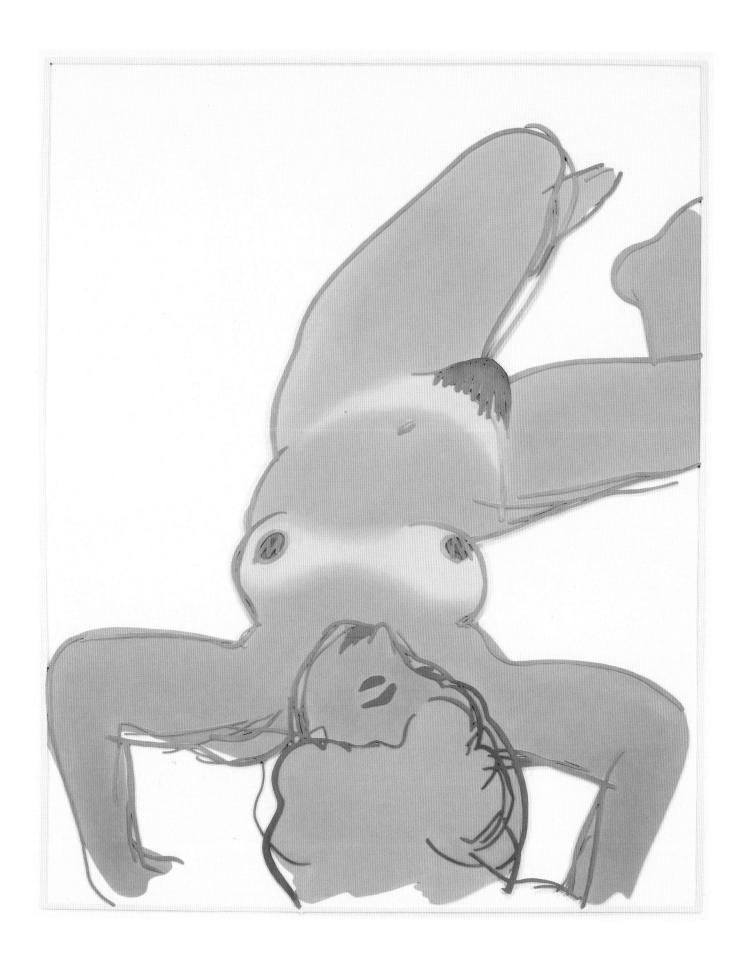

71 1962/92
1962 Hedy
Oil on cut-out steel,
147.3 x 118.1 cm

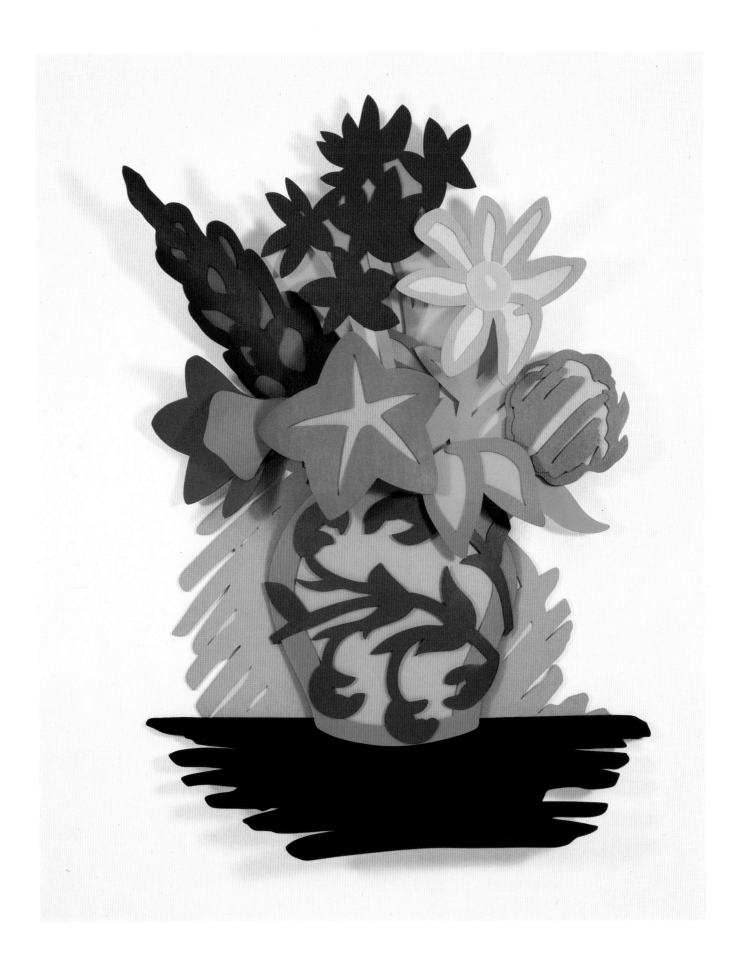

72 1993
Mixed Bouquet (Filled In)
Oil on cut-out aluminium,
188x132.1x19.1 cm

Studies and Drawings

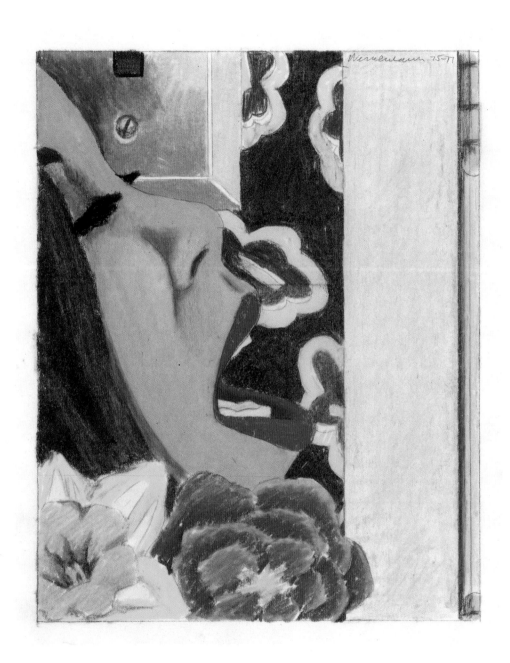

73 1975/77
Study for a Bedroom Face
Colored pencil on tracing paper,
16.3 x 13.1 cm

74 1960
Drawing for Judy Undressing
Pencil on paper,
32.7 x 24.1 cm

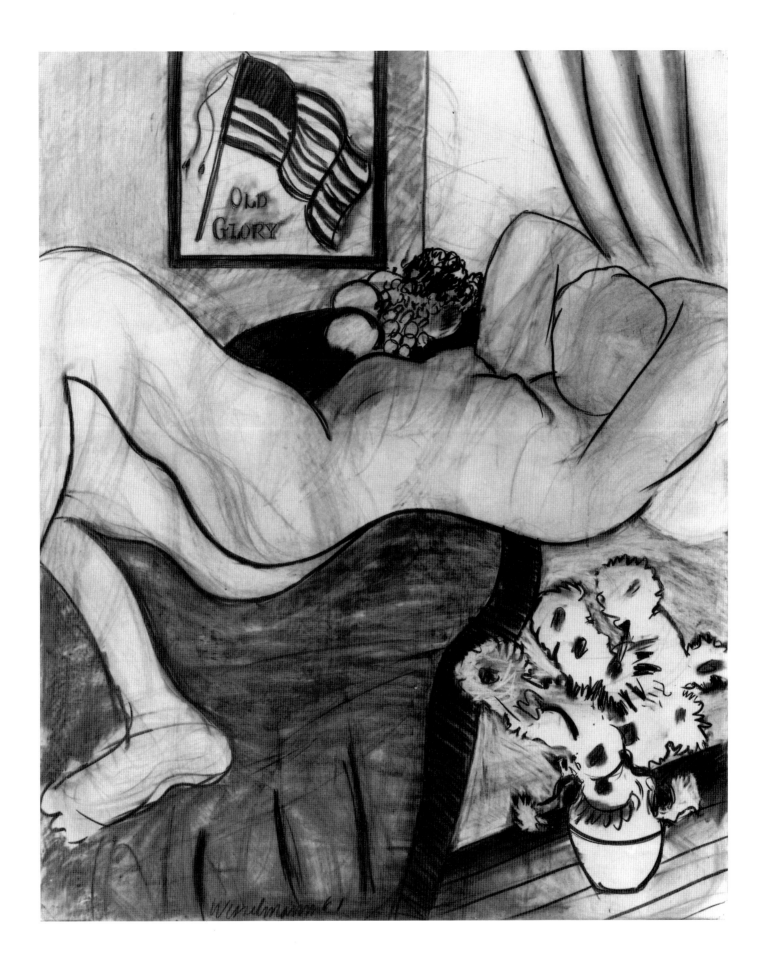

75 1961
Drawing for Great American Nude # 20
Charcoal on paper,
152.4 x 121.9 cm

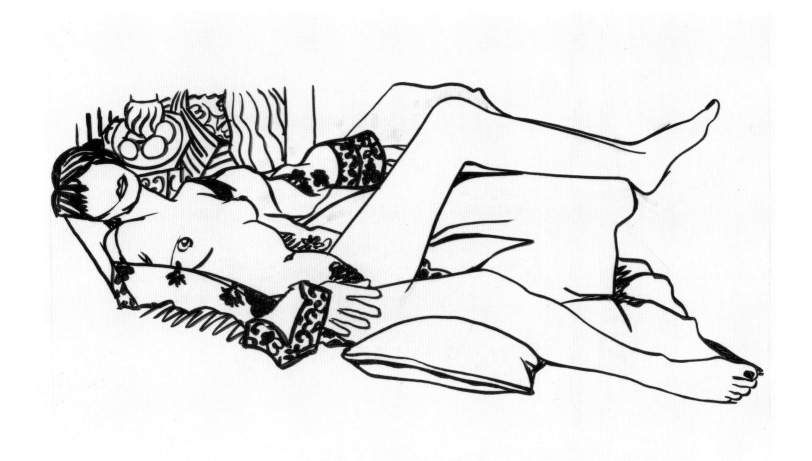

76 1987
Drawing for Monica Nude and the Purple Robe
Ink on paper,
66 x 101.6 cm

77 ¹⁹⁸⁴
Drawing: Amy
Pastel pencil on paper,
37.5 x 58.4 cm

78 1991
Reverse Drawing: Still Life with Two Matisses
Charcoal and pencil on rag board,
144.8 x 180.3 cm

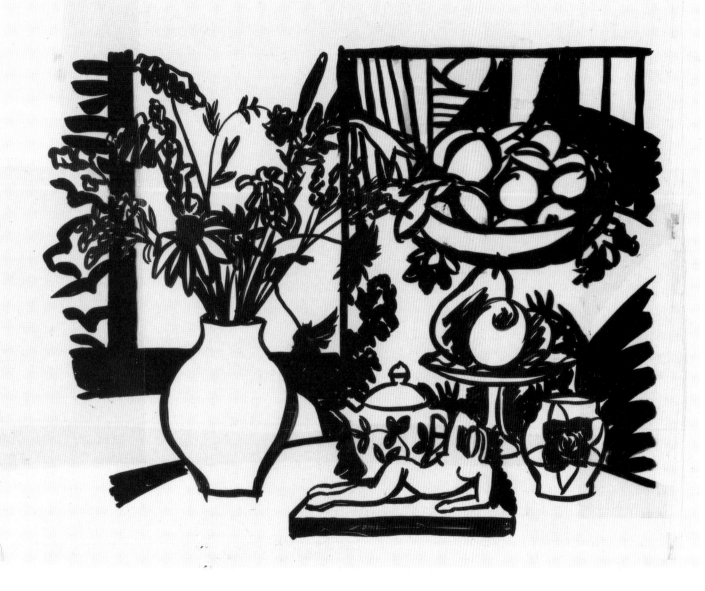

79 1990
 Drawing for Still Life with Two Matisses
 Ink on paper and acetate,
 54 x 66 cm

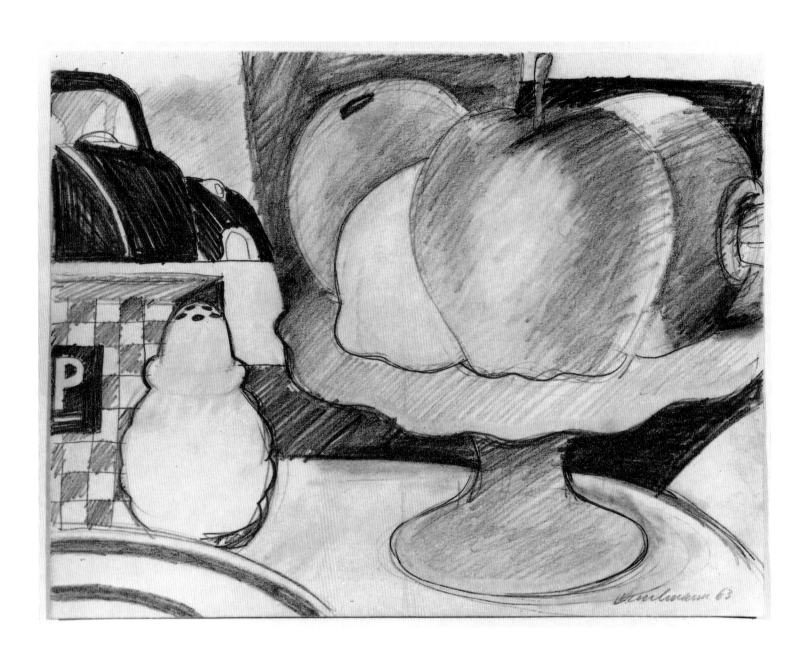

80 ¹⁹⁶³
Drawing for Still Life # 29
Pencil on paper,
21.6 x 27.9 cm

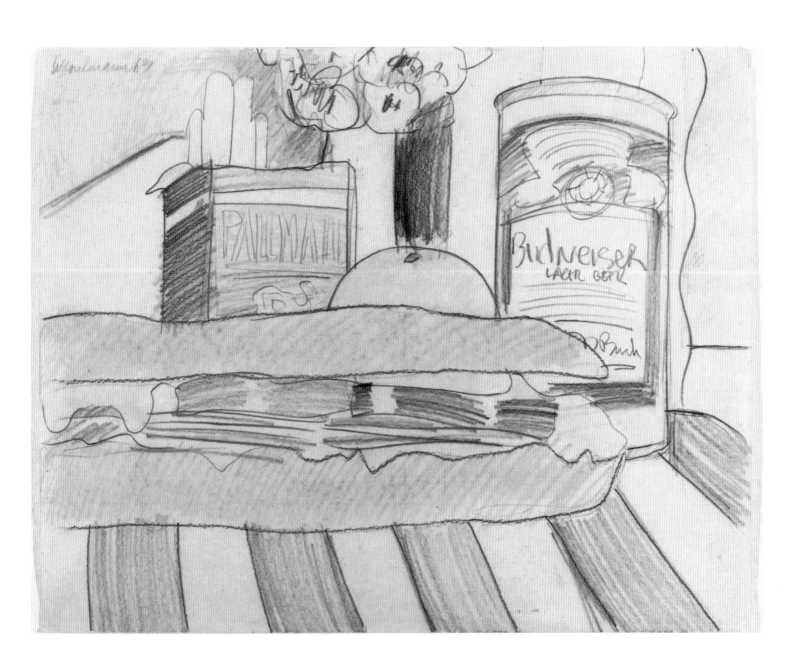

81 ¹⁹⁶³
Drawing for Still Life # 33
Pencil on paper,
43.2 x 55.9 cm

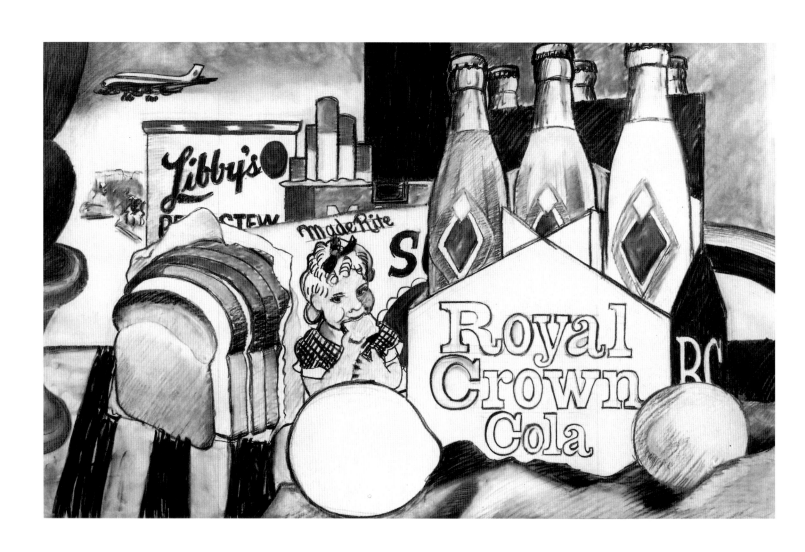

1963
Drawing for Still Life # 35
Charcoal on paper,
76.2 x 121.9 cm

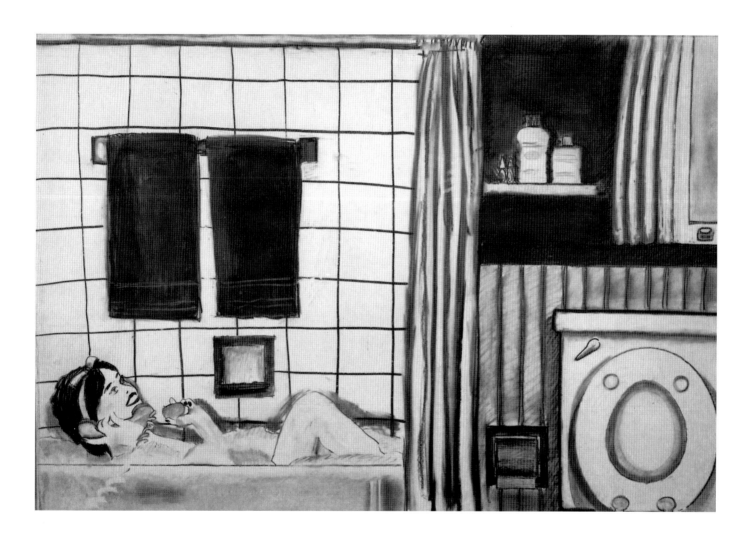

83 1963
Drawing for Bathtub Collage # 2
Charcoal on paper,
121.9 x 182.9 cm

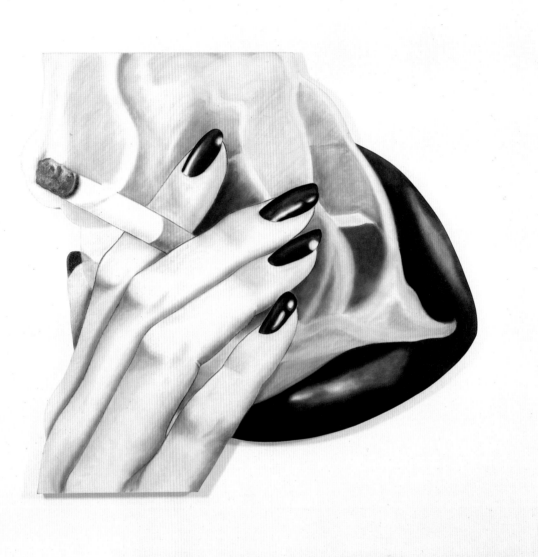

84 1974
Drawing from Smoker # 9
Charcoal on canvas,
210.8 x 227.3 cm

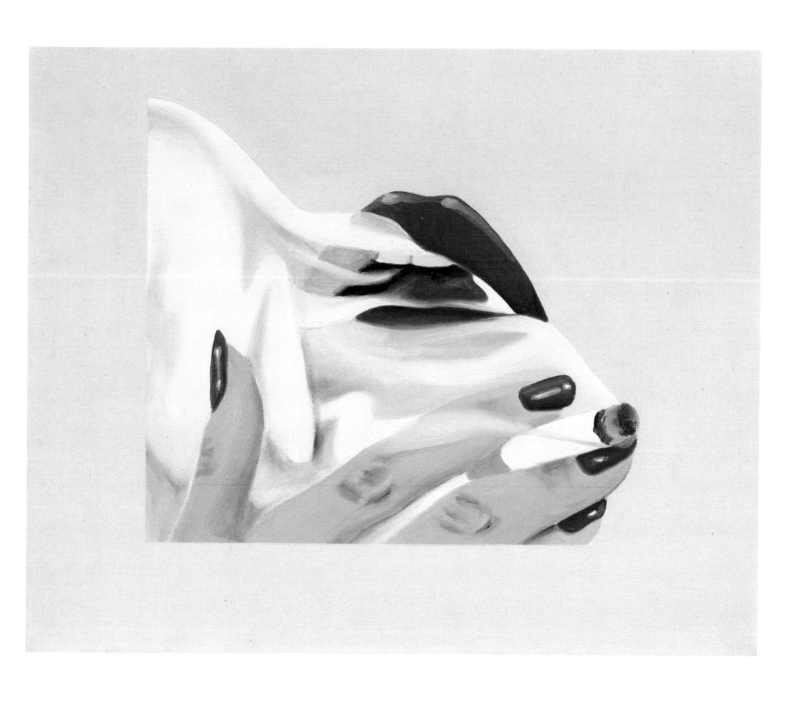

85 ¹⁹⁷⁴
Smoker Study (for Smoker # 13)

Oil on canvas,

30.5 x 38.1 cm

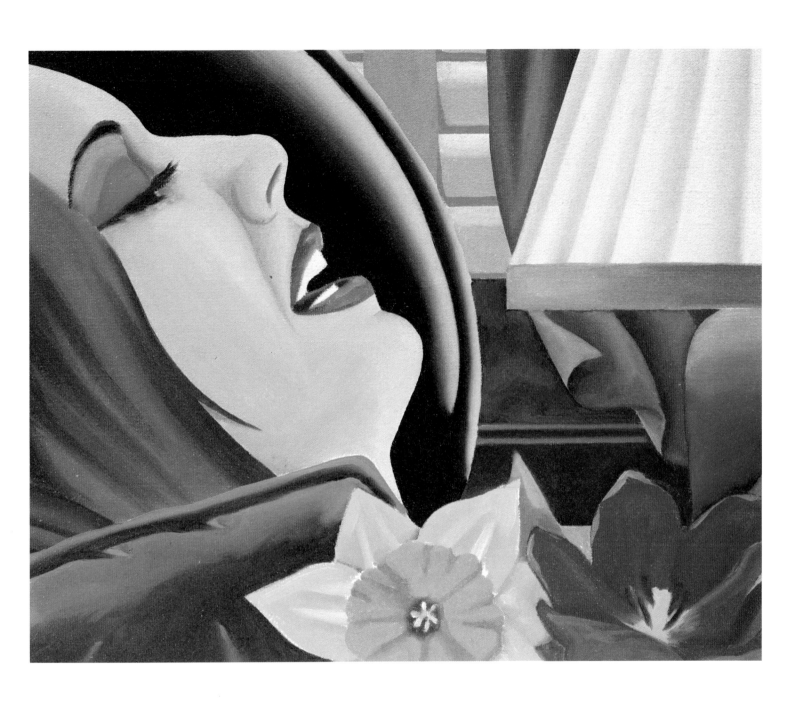

86 1977
Study for Bedroom Painting # 39
Oil on canvas,
27.9 x 31.1 cm

87 ¹⁹⁸³
Study for Bedroom Painting # 64
Pencil and colored pencil on tracing paper,
10.2 x 19.1 cm

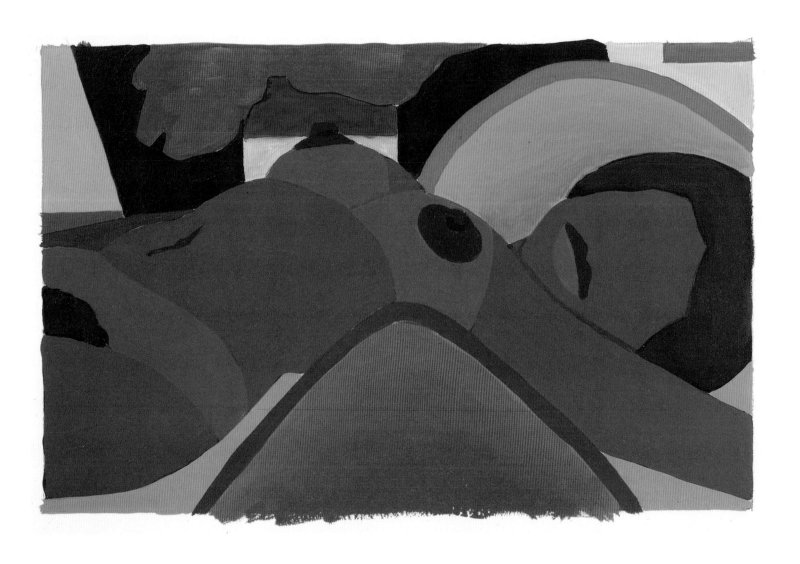

88 1971
Study for Big Brown Nude
Liquitex on Bristol board,
14 x 22.2 cm

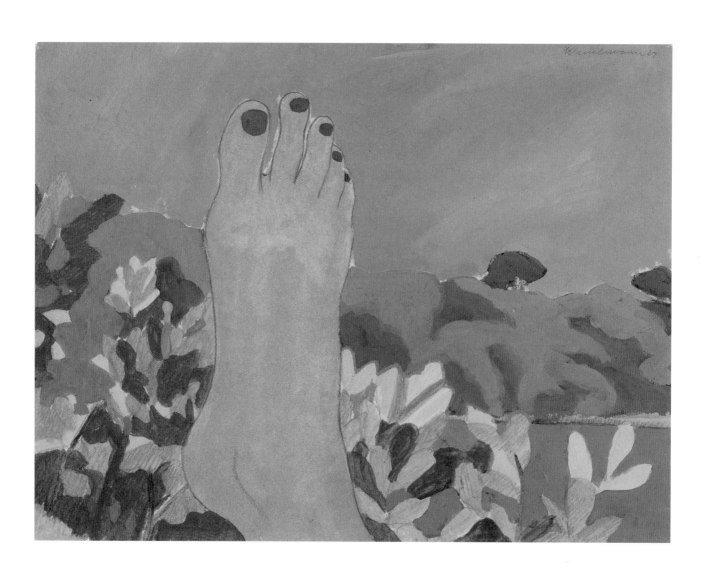

89 1967
Cape Cod Foot
Pencil and Liquitex on paper,
22.5 x 30.2 cm

90 1990
Maquette for Seascape with Clouds (3-D)
Liquitex on Bristol board,
9.5 x 39.4 x 1.3 cm

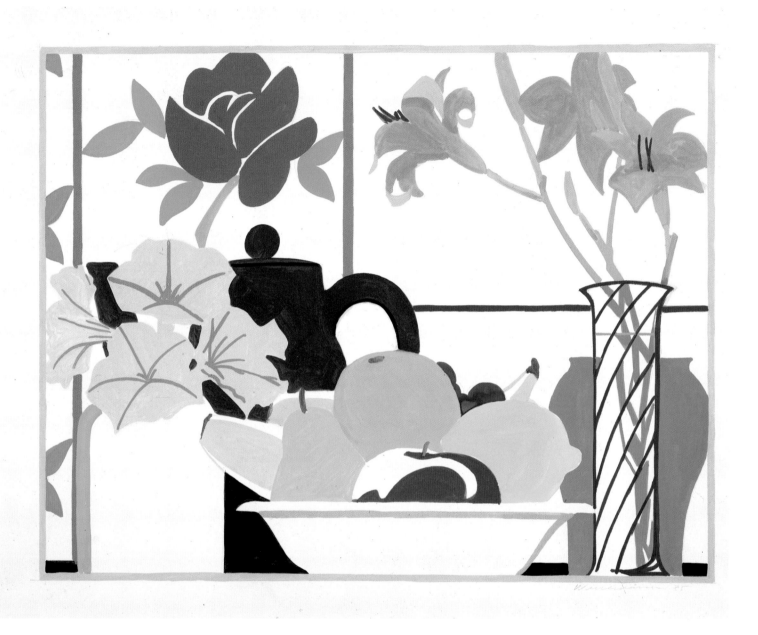

91 1985
Study for Still Life with Petunias, Lilies and Fruit

Pencil and Liquitex on Bristol board,

33.7 x 41.3 cm

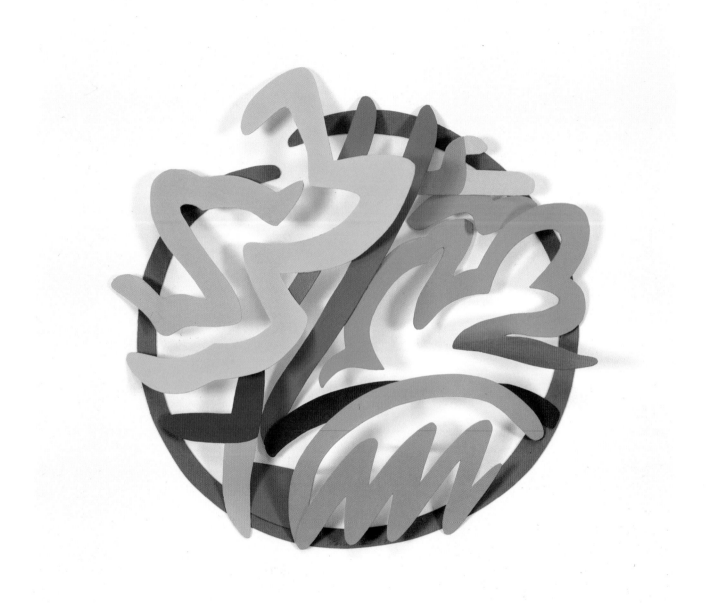

92 1987
Maquette for Still Life with Orange, Tulips and Trees (3-D)
Pencil and Liquitex on Bristol board,
40.6 x 41.9 cm

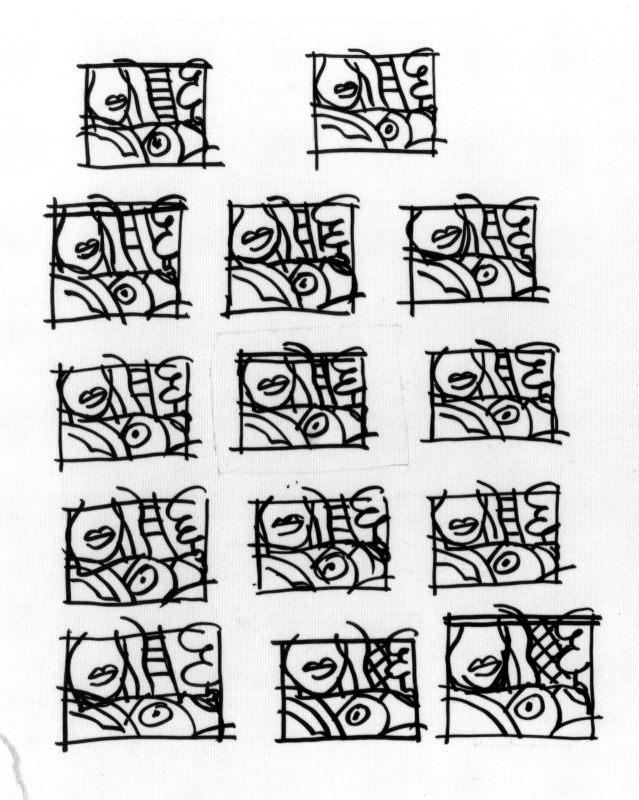

93 1985
Page of Doodles for Nude with Green Drape
Marker on paper,
33 x 29.2 cm

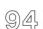 94
1984
Bedroom Blonde Doodle with Photo
Liquitex on Bristol board,
147.3 x 172.7 cm

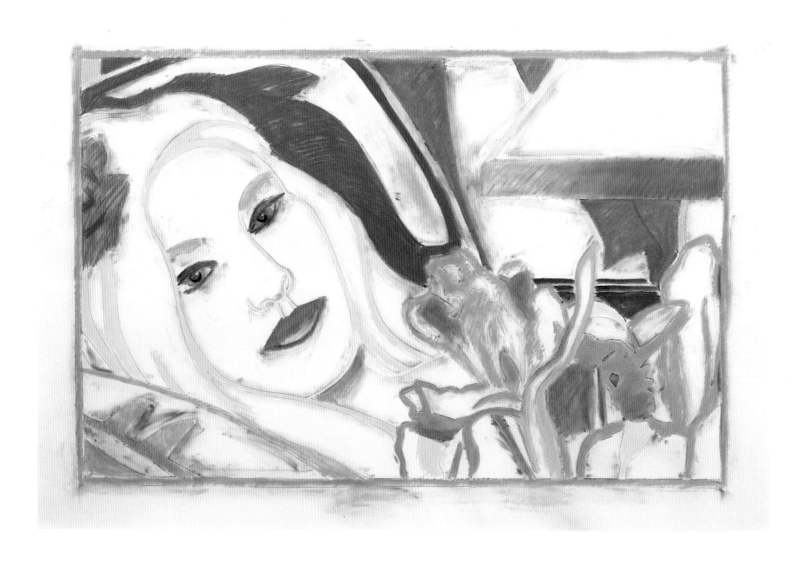

95 ¹⁹⁹³
Reverse Drawing: Bedroom Blonde with Irises

Charcoal and pastel on paper,

165.1 x 241.3 cm

Sculptures

Sculptures

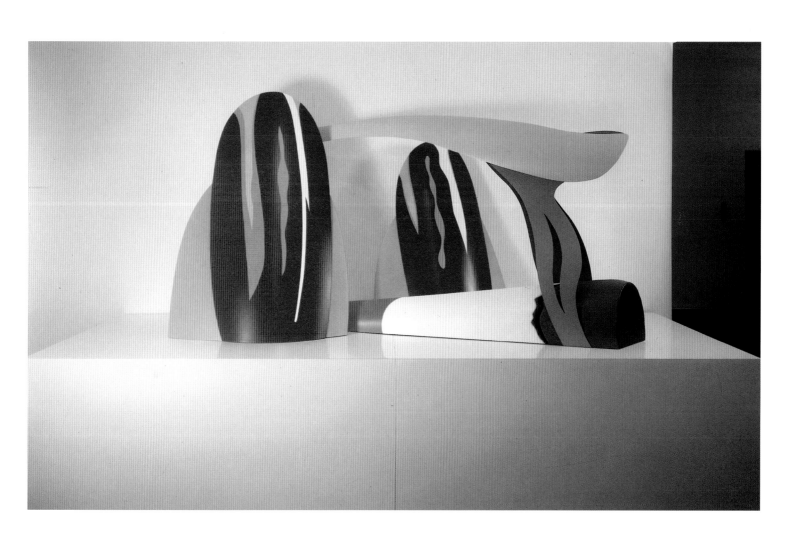

96 1978–89
 Big Maquette for Smoker Sculpture
 Enamel on masonite and formica base,
 218.4 x 368.8 x 121.9 cm

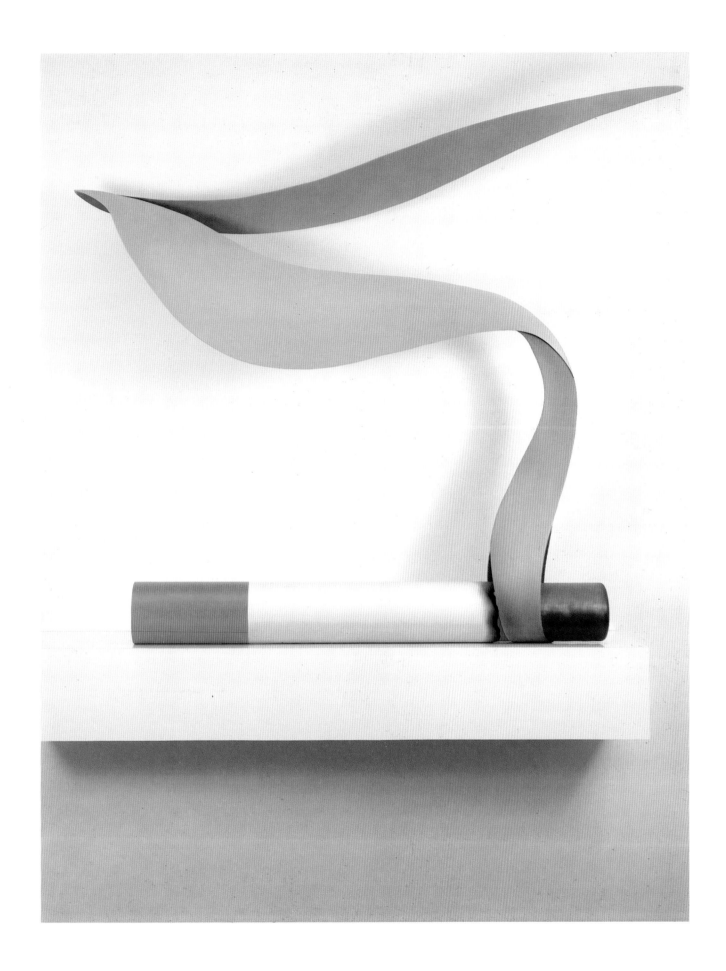

97 ¹⁹⁸⁰
Smoking Cigarette # 2

Oil on masonite and wood formica base,
174.3 x 201.3 x 45.7 cm

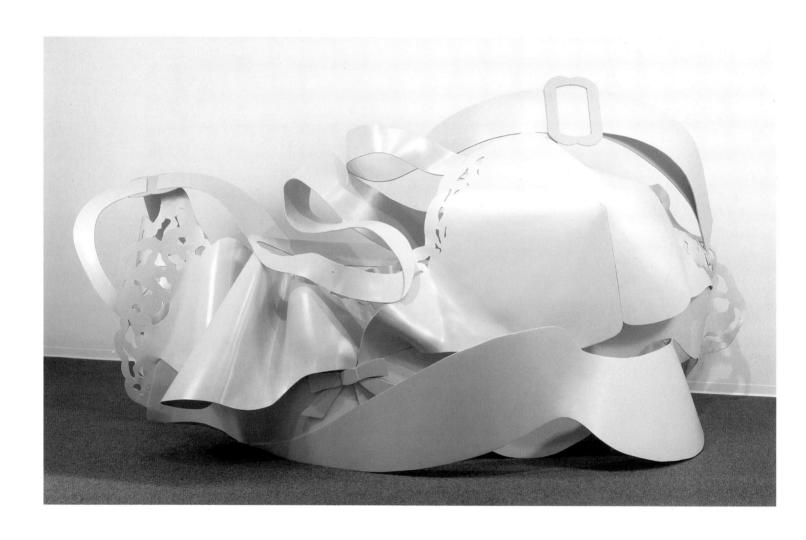

98 1980
Dropped Bra (Pink)
Enamel on aluminium,
182.9 x 391.2 x 213.4 cm

List of works

Public Collections

USA

The Museum of Modern Art, New York

Whitney Museum of American Art, New York

Albright-Knox Art Gallery, Buffalo

Princeton University Art Museum

Hirshhorn Museum and Sculpture Garden, Smithsonian Institution, Washington, D.C.

Honolulu Museum of Contemporary Art

The National Museum of American Art, Smithsonian Institution, Washington, D.C.

Rose Art Gallery, Brandeis University, Waltham

Worcester Art Museum

Washington University Gallery of Art, Saint Louis

Nelson-Atkins Museum, Kansas

Sheldon Memorial Art Gallery, University of Nebraska, Lincoln

Walker Art Center, Minneapolis

Minneapolis Institute of Fine Arts

Milwaukee Art Museum

Dallas Museum of Fine Arts

Rice University, Houston

University of Texas, Austin

Cincinnati Art Museum

University of Kansas Museum of Art, Lawrence

Philadelphia Museum of Art

Virginia Museum of Fine Arts, Sydney & Francis Lewis Collection, Richmond

Chrysler Museum, Norfolk

Europe

Tate Gallery, London

Staatliche Museen zu Berlin, Nationalgalerie

Forum Ludwig, Aachen

Museum Ludwig, Cologne

Kaiser-Wilhelm-Museum, Krefeld

Nasjonalgalleriet, Oslo

Louisiana Museum of Modern Art, Humlebaek

Musée d'Art et d'Industrie, Saint-Étienne

Israel Museum, Jerusalem

Museum für Moderne Kunst, Frankfurt am Main

Japan

The Museum of Modern Art, Toyama

The Tokushima Modern Art Museum

The Museum of Modern Art, Shiga

Iwaki City Art Museum

Hara Museum of Contemporary Art, Tokyo

Hakone Open-Air Museum of Art

New Tokyo Metropolitan Museum of Modern Art

Selected Bibliography

General Books

Alloway, Lawrence. *American Pop Art.* New York: Collier Books and London: Collier Macmillan, in association with the Whitney Museum of American Art, 1974.

Amaya, Mario. *Pop as Art: A Survey of the New Super-Realism.* London: Studio Vista, 1965.

Codognato, Attilio. *Pop Art: Evoluzione di una generazione.* Milan: Electa, 1980. [Includes interview with Wesselmann by David Shapiro.]

Dubreuil-Blondin, Nicole. *La Fonction critique dans le Pop Art américain.* Montreal: Les Presses de l'Université de Montréal, 1980.

Hunter, Sam. *Tom Wesselmann.* London: Academy Editions, 1994.

Lipman, Jean and Steinberg, Leo. *Art about Art.* New York: E. P. Dutton, in association with the Whitney Museum of American Art, 1978

Lippard, Lucy, R. *Pop Art.* London: Thames and Hudson and New York: Frederick A. Praeger, 1966, revised 1967 and 1970.

Livingstone, Marco. *Pop Art: A Continuing History.* London Thames and Hudson and New York: Harry N. Abrams, 1991. Foreign editions published in 1991 in French by Hachette, Paris, and in Italian by Leonardo, Milan.

Mahsun, Carol Anne. *Pop Art and the Critics.* Ann Arbor: U.M.I. Research Press, 1987.

–, ed. *Pop Art: The Critical Dialogue.* Ann Arbor: U.M.I. Research Press, 1988.

Osterwold, Tilman. *Pop Art.* Cologne: Benedikt Taschen, 1990. [German and English editions.]

Rublowsky, John. *Pop Art: Images of the American Dream.* New York, 1965.

Russell, John and Gablik, Suzi. *Pop Art Redefined.* London: Thames and Hudson and New York: Frederick A. Praeger, 1969.

Sandler, Irving. *American Art of the 1960s.* New York: Harper & Row, 1988.

Seitz, William C. *Art in the Age in Aquarius, 1955–1970.* Washington, DC: Smithsonian Institution Press, 1992.

Tono, Yoshiaki, editor. *The Pop Image of Man.* Art Now, 4. Tokyo: Kordansha Ltd, 1971.

Catalogs of Major Group Exhibitions

New Realists, text by John Ashbery, Pierre Restany and Sidney Janis. New York: Sidney Janis Gallery, November 1 – December 1, 1962.

The Popular Image, text by Alan Solomon. Washington, DC: Washington Gallery of Modern Art, April 1963.

Amerikansk Pop-Kunst, text by Alan Solomon and Billy Kluver. Stockholm: Moderna Museet, February 29 – April 12, 1964.

Pop Art 1955–1970, text by Henry Geldzahler. International Cultural Corporation of Australia Ltd, under the auspices of the International Council of The Museum of Modern Art, New York.

Pop Art U.S.A. – U.K., texts by Lawrence Alloway, Marco Livingstone and Masutaka Ogawa. Tokyo: Odakyu Grand Gallery, 1987, and Japanese tour.

Pop Art, edited by Marco Livingstone. London: Royal Academy of Arts, September 13 – December 15, 1991, distributed by Weidenfeld & Nicolson, London, and Rizzoli, New York. Foreign editions published in 1992 in Germany by Prestel Verlag, Munich; in Spanish by Electa España, Madrid; and in French by the Montreal Museum of Fine Arts.

Exhibition Catalogs and Books on the Artist

Tom Wesselmann, a substantial monograph written by the artist under the pseudonym Slim Stealingworth, was published in New York by the Abbeville Press in 1980.

Catalogs have been published by the Sidney Janis Gallery, New York, for Wesselmann's one-man shows there in 1966, 1968, 1970, 1972, 1974, 1976, 1979, 1980, 1982, 1983, 1985, 1987, 1988, 1990 and 1992. With the exception of the 1992 catalog, which contains a pseudonymous introduction by the artist, these consist of reproductions only, with no text.

Tom Wesselmann: The Early Years. Collages 1959–1962. Text by Constance Glenn. Long Beach: Art Galleries, California State University, November 10 – December 8, 1974 and tour to Trisoli Gallery of Ohio University, Athens, Ohio, and Nelson Gallery – Atkins Museum, Kansas City, Missouri, 1975.

Tom Wesselmann: Drawings, essay by Ileen Sheppard. Flushing, New York: Queens Museum, March 21 – May 10, 1987.

Wesselmann: Recent Works. Introductory essay by the artist, published under his pseudonym, and essay by Masutaka Ogawa. Tokyo: Galerie Tokoro, May 9 – June 16, 1988.

Tom Wesselmann: Paintings 1962–1986. Introduction by John McEwen. London: Mayor Gallery and Mayor-Rowan Gallery, July – August 1988.

Tom Wesselmann. Introduction by Trevor Fairbrother. London: Waddington Galleries, June 21 – July 15, 1989.

Wesselmann (Prints and Multiples). Tokyo: Hara Museum of Contemporary Art, April 28 – June 10, 1990.

Tom Wesselmann: Black and Gray. London: Edward Totah Gallery and Milan: Galleria Seno, 1991.

Tom Wesselmann: Recent Still Lifes and Landscapes. Introduction by Sam Hunter, and essay by Tatsumi Shinoda, Tokyo: Galerie Tokoro, October 7 – November 14, 1991.

Tom Wesselmann: A Retrospective Survey. Introduction and catalog essays by Marco Livingstone, additional essay by Masao Kobayashi. Tokyo: Isetan Museum, September 15 – October 12, 1993 and Japanese tour.

Videos on the Artist

In 1992 the Drawing Society produced a video, under the guidance of Paul Cummings, showing the artist drawing from the model and then following through with one of his metal works.

A video lasting approximately fifteen minutes, directed by Mick Rock, was made in 1993 to accompany the Japanese and European touring retrospective.

Articles and Interviews

Abramson, J. A. "Tom Wesselmann and the Gates of Horn." *Artsmagazine,* vol. 40, no. 7, May 1986, pp. 43–48.

Beckers, Walter. "Interview: Tom Wesselmann." *Winners Magazine,* XXX/II, no. 30, 1986, pp. 3–5.

Burdon, David. "Eroticism Comes in Many Colors." *The Village Voice,* May 10, 1976.

Clark, Phillippe-Evans. "Tom Wesselmann dans la tradition de l'expressionisme abstrait." *Art Press,* no. 114, May 1987, pp. 4–9.

Fairbrother, Trevor J. "An Interview with Tom Wesselmann/Slim Stealingworth." *Arts Magazine,* May 1982, pp. 136–141.

Gardner, Paul. "A Talk with Tom Wesselmann." *ART-news,* January 1982, pp. 67–72.

Giaccetti, Romano. "Tom Wesselmann." *Epoca,* no. 1641, March 19, 1982, pp. 70–75.

Goodson, Michael. "Wesselmann: All the Nudes Fit to Print." *Real Paper* (Boston), June 4, 1978.

Karlins, N. F. "The Smoker as Sex Object." *East Side Express,* May 27, 1976.

Kramer, Hilton. "Form, Fantasy, and the Nude." *The New York Times,* February 11, 1968.

Liebmann, Lisa. "Tom Wesselmann." Review of exhibition at Sidney Janis Gallery. *Artforum,* September 1982.

Mc Carthy, David. "Tom Wesselmann and the Americanization of the Nude, 1961–1963." *Smithsonian Studies in American Art,* vol. 4, nos 3–4, Summer/ Fall 1990, pp. 103–127.

McGill, Douglas C. "Art People: Tom Wesselmann in an New Medium." *The New York Times,* November 22, 1985.

O'Doherty, Brian. "Art: 'Pop' Show by Tom Wesselmann is Revisied." *The New York Times,* November 28, 1962.

Ratcliff, Carter. "Tom Wesselmann." *Art International,* special summer issue 1970, pp. 131, 140.

–, "Reviews: Tom Wesselmann." *Artforum,* January 1973, p. 82.

Raynor, Vivien. "Wesselmann: The Mockery Has Disappeared." *The New York Times,* May 12, 1974.

Swenson, G. R. "What is Pop Art? Interviews with eight painters." Part II, *ARTnews,* February 1964, pp. 40–43, 62–67.

–, "Wesselmann: The Honest Nude." *Art and Artists,* vol. 1, no. 2, May 1966, pp. 54–57.

Tallmer, Jerry. "Women bursting out all over." *The New York Post,* May 12, 1979.

"Tom Wesselmann." *Mizue Magazine* (Japan), no. 786, September 1970, pp. 60–75.

Wesselmann, Tom. Letter to the editor. *ARTnews,* vol. 62, no. 4, Summer issue, 1963.

–, Statement in *ARTnews,* November 1985, p. 93.

Wilson, William. "Wesselmann: Portrait of an Artist's Blue Period." *The Los Angeles Times,* December 2, 1974.

Zelenko, Lori Simmons. "Tom Wesselmann." *American Artist,* June 1982, pp. 58–63, 102–103.

Editors
Thomas Buchsteiner, Otto Letze

Exhibition/Tour Organization
Institut für Kulturaustausch, Tübingen

Editorial Staff
Sabine Bergmann, Angelika Eberhardt, Tina Keck

Translations
John Southard, David Sterner

Graphic Design
Karin Girlatschek

Production
Dr. Cantz'sche Druckerei, Ostfildern

Photographs
André Großmann, Eric Pollitzer, Jim Strong,
Claire Wesselmann

English Edition
ISBN 3-89322-636-2

German Edition
ISBN 3-89322-635-4

Cantz Verlag
Senefelderstraße 9
D-73760 Ostfildern
Tel. 07 11/4 49 93 - 0
Fax 07 11/4 41 45 79

Distribution USA
D.A.P.
Distributed Art Publishers
636 Broadway, RM 1200
New York, N.Y. 10012
Tel. 2 12/4 73 - 51 19
Fax 2 12/6 73 - 28 87

Printed in Germany

Front Cover
Great American Nude # 53

Back Cover
Seattle Tulip

This catalogue is published as an accompaniment to the exhibition tour
organized by the Institut für Kulturaustausch in Tübingen and realized through
the generous support of the Mercedes-Benz AG at eleven major European
museums during the period 1994 to 1997.